SMALL TOWN LIVING

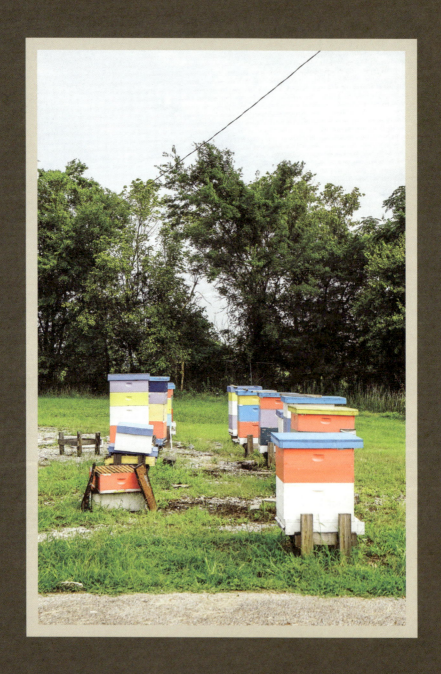

SMALL TOWN LIVING

A Coast-to-Coast Guide to People, Places, and Communities

ERIN AUSTEN ABBOTT

Foreword by Erin Napier

Running Press
PHILADELPHIA

Running Press
Hachette Book Group
1290 Avenue of the Americas, New York, NY 10104
www.runningpress.com
@Running_Press

First Edition: September 2024

Published by Running Press, an imprint of Hachette Book Group, Inc. The Running Press name and logo are trademarks of Hachette Book Group, Inc.

The Hachette Speakers Bureau provides a wide range of authors for speaking events. To find out more, go to www.hachettespeakersbureau.com or email HachetteSpeakers@hbgusa.com.

Running Press books may be purchased in bulk for business, educational, or promotional use. For more information, please contact your local bookseller or the Hachette Book Group Special Markets Department at Special.Markets@hbgusa.com.

The publisher is not responsible for websites (or their content) that are not owned by the publisher.

Print book cover and interior design by Jenna McBride

Library of Congress Control Number: 2024932879

ISBNs: 978-0-7624-8429-4 (hardcover), 978-0-7624-8430-0 (ebook)

Printed in China

APS

10 9 8 7 6 5 4 3 2 1

For Tom Otis and Sean

CONTENTS

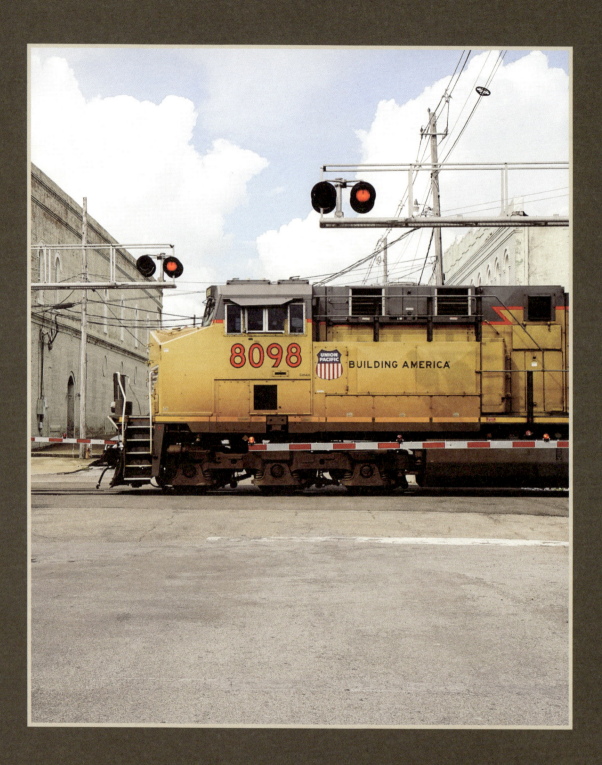

FOREWORD

I have lived in small towns my entire life, though that was not the plan. As a teenager in rural Mississippi, I fantasized about an adult life in San Francisco, where I would thrift shop in Haight-Ashbury and dress in vintage kimonos, taking walks around the corner to the bodega for my groceries. I did not imagine a family or husband in this future: I would be too busy enjoying my life to need more people in it. Sometimes the fantasy transferred my life to New York City, a place I had never been but felt like I had, because I'd seen enough movies to understand it was where the good bagels came from. Also, you could only truly fall in love or have a cinematic breakup if you took walks in Central Park, wearing an appropriately oversized sweater. I would be Estella in *Great Expectations*, Sara Deever in *Sweet November*, Amélie Poulain in Montmartre. My life would be rich because of the richness of culture around me, once I was away from the small-mindedness of my childhood home. In those places, in my mind's eye, art and food and beauty were true and real, and money would not matter. My no-doubt pitiful accommodations would all be in service of living the great, big-city dream. As Joan Didion wrote, "We tell ourselves stories in order to live." I told myself many stories, all about how my potential would rot like fruit left on the vine if I weren't plucked out of Mississippi—and quickly.

As I entered my twenties, working two jobs through college to keep gas in my car and food in my tiny apartment fridge at Ole Miss, I experienced a longing that was more than surprising: it was disconcerting. What I felt was

a desire to go back to my hometown of Laurel, Mississippi. It was a pang that hit me weekly, and at first it was easy to dismiss. I had fallen in love with Ben, another product of small town Mississippi, born out of a crush I'd had for so long I had turned him into a celebrity in my mind. Because of his magnetism, sheer physical size, and generosity of spirit, I felt he could be anything, go anywhere, and do whatever he wanted in life. I was his, and I was along for the ride; a world of opportunities lay ahead of us. Being Ben's girlfriend put me beyond my small town upbringing, I thought. I was *more* with his arm around me. I didn't care where we were; his love was the same great reward as finding a life for myself in a big city.

Then a Conway Twitty song playing in a gas station would set off pinpricks in my heart that made me ache for something: a do-over. The song brought back the best of my childhood in a rush—my parents, young and building a farm in the 1980s, with the brick two-story house in the country where I first learned about art and music. Painting with my mother after school—I thought she was a professional artist for most of my early childhood. Though where we lived was rural, my parents took us places, taught us things, and showed us a great big world outside of Jones County. Our life was an adventure wherever we went. I'm not sure why I felt that magic and adventure were no longer available to me as a teenager. I guess hormones tell us stories, too. Regardless of where we are planted, though, we can either choose to participate in the magic of the mundane or to complain about what we wish was better or different. I had become a person who complained until I met Ben, and then I remembered who I really was. I was a person who could bloom in any soil. He watered the soil in my heart that told me I needed to return home.

By the time I graduated from college, I had seen Great Britain, California, and New York City, and I had decided they all had problems, too—same as Laurel, same as anywhere. There is no perfect place, but there are places where connection, friendship, community, and family ties are easier to be part of, places that are made stronger and make us better. In small towns, we each matter so much more. Our presence and gifts are the lifeblood of these places, and we are free to live instead of just survive. In small town

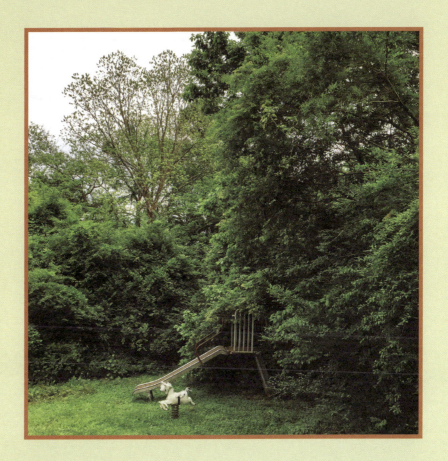

America, you find the flavor of our country. America's great eccentricities, failures, cultures, legends, and traditions mingle in surprising and delicious ways in town festivals and heroes. In Laurel, there is an annual crawfish boil and anvil shoot held by the Mulloy family, where thousands attend to listen to the blues, eat crawfish, and blast a 120-pound iron anvil into the sky with explosives to see how high it will go. This is odd. We know this. We celebrate it. And because our town is small, it's a distilled and highly concentrated sort of legend. The fish are very big in our stories because the place isn't.

Perhaps our greatest asset and failing is this: in small towns, there are no secrets and no strangers. Your neighbor will know your story, for better or for worse, but it's most often out of genuine concern for your life. We aren't alone in these communities. We have support and kinship because also, for better or worse, we are on the same team when we choose to live our lives

bound up together in a small town. We root for the team—and we complain about it too—but it is ours, and we won't abide the criticism of an outsider.

I regret how I felt about small town America when I was younger. I was foolish. I didn't realize I could own my dream home for a fraction of the cost of a small apartment in a heavily populated city. I didn't realize I could change the things that needed changing here. I didn't realize I could appreciate even more things I once thought needed changing but later realized didn't. It was me all along who needed to change. We are good at ignoring the faults of our neighbors here, regardless of who they voted for. We consciously look for the good in the individual and politely avoid the conversations that might create division. It's a small town discipline, I now know: if we're going to be in each other's business, we've got to get along. To that end, we've also got to support each other's businesses if our towns are going to thrive. In downtown Laurel, there is a shop that sells cookie dough and also ladies' dresses. We do not have fusion restaurants, but on the first weekend in December, we stand together on the sidewalks to wait for all-you-can-eat pancakes and sausage at the YWCO, and we sing the carols our grandparents sang when the Christmas tree is lit in Pinehurst Park. For what we lack, we are rich in other ways. We can all be big fish in these small ponds, and in small town America, that's a kind of immortality.

ERIN NAPIER

co-host of *Home Town* on HGTV with her husband Ben Napier
and co-owner of Laurel Mercantile in Laurel, Mississippi

PREFACE

I wanted to write this book for several reasons. After living in a small town for more of my life than not, I've seen many things that work in different communities, as well as many things that have fallen flat or were received differently by the longtime locals and the newcomers. Through reading this book, you will see the difference between the two, and will grow to understand how to navigate your small town living, whether it's a new experience or you've been here all along. With so many people wanting to move to small towns these days, we are seeing a shift away from the idea that you have to be in a city to have the life you want. I hope you will use this book as your tool for that transition.

There are many ideas for events and businesses to start in your new town, and for ways to offer your time, but at the core of it all, you will come to understand what it means to create a community for yourself or to add to the one that was there before you arrived. I hope you will use this book as a guide not only for discovering places you otherwise haven't been, but also as a tool to learn what you could bring to your communities. Throughout these pages, you will find images of towns and people from across the country, but small town stories are not limited to just these people and places. There are over 19,000 small towns in the United States alone. (According to Census.gov, in 2020 there were 19,500 incorporated towns with a population under 25,000 in the United States.) And each and every one has a story to tell. I wish that I could be the one to tell them all.

My son and I traveled through dozens of small towns to take pictures for *Small Town Living*. We drove the back roads any chance we had, past abandoned storefronts and through lively, thriving downtowns; yet at the forefront of every place, there was still heart and light, even in those desolate stretches when you don't see another car. Sometimes you are left to wonder, *How did people find this land?* You are reminded that many people before you *did* find it and loved the land and gained purpose and meaning in the solitude.

On the drives, in between towns, I had time to think about the trees that line the roads. I wondered what it was like when these tall, towering sentinels were just seedlings.

I thought about the generations of families that had been living on the land for many, many years. I thought about the Indigenous families who made this their home even earlier. Are we good stewards these days? How can we do better? What can we do to create more inclusive communities for everyone?

It all has meaning and purpose. You see the potential and growth of a small town, and you see the heart; that is why I wanted to write this book. Crisscrossing back roads, looking for places to stop and visit, gives you time to think and time to imagine what could be. There's something magical about the blank canvas of a small town. And there is something fascinating

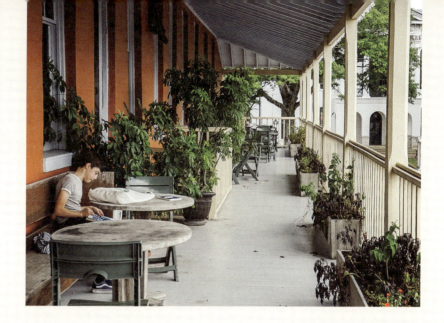

about passing through a small town and seeing abandoned buildings—kudzu covering the windows, boards falling in, nails rusting—and thinking: *Is this my mark on the Earth? Is this what I'm leaving behind? How did we get here? Why are we so quick to leave and move on? How did these structures become so worthless while they rest in a place that, at one time, someone wanted to call home? A place we found so much value in and then were so quick to walk away from.*

There are dozens and dozens of these abandoned spots, buildings, and towns just waiting for us to breathe new life into them. This book will share the stories of some who have started that process and give you the tools to do so as well. Think of this book as a map to navigate your own small town move, understand ways to build community, and add to one that's already rooted in place. This is your chance to learn from others what works and what doesn't when you are thinking of embracing a smaller way of living.

You can use this book as a jumping-off point in what to look for in a town, applying the lists of places outlined for you as towns to consider calling home and ideas to start your small town life. There's a little something for everyone thinking of making the move to a small town and even those who just want to visit.

ERIN AUSTEN ABBOTT

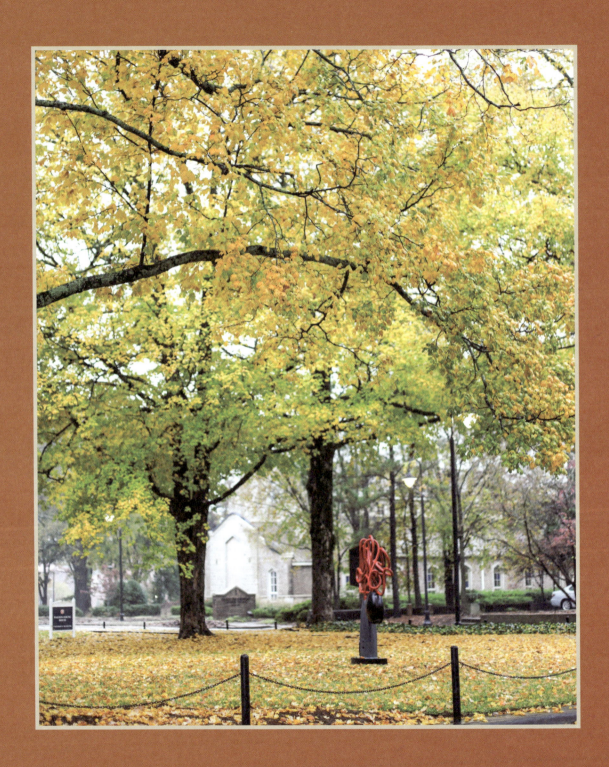

MY SMALL TOWN JOURNEY

As a child, I lived in Oxford, a small town in North Mississippi, until around fourth grade. In 1985 we moved to a different small town, about twenty-five miles outside of Tampa, Florida. Living so close to a large city like Tampa was very new to me. The town I moved from only had around 5,000 residents at the time. Land o' Lakes, Florida, wasn't much bigger than Oxford, but its proximity to Tampa made it feel vastly different. There weren't many amenities in Land o' Lakes, so we traveled to Tampa for most of our needs, which made it feel like an extension of our home.

We moved to St. Petersburg, just over the bay from Tampa, after three years in Land o' Lakes, and I found that over time I forgot what small town living was like. I spent my twenties bouncing from one city to the next—Tampa to Boston to Seattle to San Francisco to Memphis to New York City, then back to Memphis.

Growing tired of the day-to-day, fast-paced, bustling from place to place, living out of a bag when I needed to be gone all day for the grind of city living, I knew it was time to make a change and get out of the bubble I found myself in. My cost of living was so high, forcing the kind of spending that would never help me see my goals come to fruition. I knew it was time to start looking elsewhere. As I had this aha moment, I dove into looking for a small town. I needed my small town to be within an hour from a city, near an international airport, and near a university, with a good live music scene, and the ability to evoke the same feeling I had for the small town we had left

when I was just nine years old. The eureka moment came when I realized that I *could* move back to the small town I left as a child. Oxford had seen a lot of growth since then, though, so I looked a little farther out.

I bought my house in January of 2005 in Water Valley, Mississippi, just fifteen minutes from Oxford, which is home to the University of Mississippi, and just a little over one hour from Memphis, Tennessee. For only $65,000, I got a beautiful Folk Victorian built in 1890. The cost of living in Water Valley also afforded me the ability to move to a new city for a few months out of the year if I so chose. I moved to Los Angeles for a short time early into my residence in Water Valley, but I have been grounded here ever since.

When I decided to move to Water Valley, I didn't know how to find the essential things, like a plumber or a realtor. I didn't know how to meet new people or get involved in my community. I didn't even think about schools because, at the time, I was single. Schools weren't even on my radar before I became a mom. But since then, I've thought about all of these things, plus about a hundred others.

I've lived in some of the world's most desirable cities, yet I still landed in a small town in rural Mississippi. Why? What drew me here? Better yet, what keeps me here? And what does it look like to raise a child in a small town? Water Valley, Mississippi, is charming and attracts many artists escaping the high cost of living in cities—they are able to be full-time, working creatives here. Its proximity to the University of Mississippi in Oxford makes it appealing as well. There will always be growth in college towns, and property investments will typically always pay off with a constant influx of people moving to the area. Having grown up in Oxford, and seeing the ways cities grow and change as neighborhoods become desirable and sought after, I understand the growth that it has experienced. More and more people began to move to the Oxford area about twenty-five years ago, and I saw the expansion toward Water Valley as the next logical direction.

I knew it was time to hang up my big-city hat and head somewhere where my ideas could make a change, instead of continuing to live in the progressive bubble of each city where I had resided. That doesn't mean that the work happening in cities isn't wonderful and very much needed—because

it is. For me, though, it was important to feel that I could bring something new to the table. Without that, I was left with the idea that I was interchangeable in my social justice and creative work. I wasn't saying anything that hadn't been said before, and it was starting to affect me. I knew that I personally needed a different environment to thrive.

Navigating my life as an adult here in Mississippi has been all about slow progression. The roots I was putting down mingled with those of the locals who were born here and never moved away. I couldn't just jump into the deep end, looking to alter everything around me as I saw fit. Instead, establishing a life here has been about blending in, taking my time, and listening to the needs of my new community.

I joined the Main Street Association—serving as vice president and helping to bring events to Main Street—and became a regular face at the farmers market, where I got to know my local growers. When my son started school, I became the vice president of the Parent Teacher Organization, getting acquainted with the teachers at the school who are also active members of

the community. I helped restart the local Episcopal church, signed up to be a poll worker during elections, and began helping out in the school library. In all these ways, I grew my roots into this place at the same time as I cultivated my role in my community. I have so many ideas that I hope to start in my town still, almost twenty years later.

Change can happen, even though it might not be overnight. And I don't think overnight change is the answer either. I'm here, working to help preserve and grow my small town in positive ways every day.

What Makes a Small Town Great?

Everyone might be looking for something slightly different when they're considering relocating, but there are still a few things that we can all agree upon when it comes to understanding what makes a small town great.

Someone who decides to move to a small town generally has one big thing in mind that draws them to a place. That big thing, that common thread among us, is *community*. The kind of community you are surrounded and supported by can make all the difference when it comes to doing without other amenities. We can live without ten different restaurant choices or a big-box store. But we as humans thrive on community. You might not want to live near a college with a lot of cultural events happening, and that's okay. Living near nature might not be what you seek, either. No matter what you are seeking, no matter where your interests lie, putting a focus on finding a community that meets your own personal interests is more important than just about anything else.

Here are some questions to ask yourself when it comes to finding the small town that's right for you:

How will I find my people?

Does this town have things that relate to my interests? For example, do you love to ride bikes? Finding a town that has a bike lane or bike trails is important, then. Is there a bike club to join, or is that something you could start? Think about how you can expand your love of biking and biking culture to your small town.

Are there social activities that will make meeting people easier? And if so, are they the type of social events that I enjoy participating in? If the town is so small that the only option is Bingo Night and you don't like to play bingo, then maybe that town isn't for you.

Is there a local place, like a coffee shop, where I can gradually get to know other like-minded people?

How does weather and climate affect me? Look for a place that aligns with your weather needs.

How does my political affiliation play a role in what I want to see in my new town?

Can I find work remotely if I can't get a job in town? Can I create my own job? Do I offer a service that is not currently being offered, but from which I could derive lots of business? Will I add to a saturated market?

What do the last ten to twenty years of growth look like for the town I'm interested in moving to?

Aside from community, other things that make a small town great are:

Cost of living

Good schools

Nature

Proximity to a larger town or city

A small scale of variety, such as a bookstore, café, coffee shop, local shopping, a farmers market

When living in a city, if you aren't finding your needs met within your neighborhood, you can move and still have access to all the things that drew you to the city in the first place. But with a small town, you are more anchored to that locale. You can't just pick up and move quite as easily. That's why really thinking about where you are moving is vital to your happiness within your new town. And it's why finding a great small town for *you* is important.

What's the Future for Small Towns?

While cities today present as hyperlocal, small towns have had this going for them all along. It's been on the calling card of what makes a small town special. You don't travel to a small town just to visit their big-box store. But you will travel to one to eat at the local bakery that sells amazing bread and muffins or to see a movie in the charming, one-screen theater you can't find in your city. Maybe you love the readings that the local bookstore has monthly or the farmers market that sells that one vegetable you didn't even know grows around you. That local, common thread is the bread and butter of a small town. When we stop shopping at our local businesses, we see the town dry up quickly. There isn't money coming in, which means there isn't tax money going to fix up our roads or fund our schools. It's all gone. When you choose to move to a small town, the future lies in keeping things local.

One of the beautiful things about small towns, as well, is that you often have a clean slate to create what you want to see in the community. You might have a hundred great ideas that wouldn't work in a city (maybe they're already being done or maybe space is an issue, etc.), but in a small town, a place that prefers slow growth, even just five of your ideas could make a lasting impression. You could be generating a model of what's to come for the town.

The future lies in slow growth, local spending, community support, and fostering ideas. I remember when I moved to Water Valley, there was no arts council. With the interest of several people, we were able to create one, and now, for over a decade we've had an arts council that hosts an art crawl each year, bouncing from artist home to artist home and giving the working artists in town a chance to thrive on the culture that we helped cultivate.

What Size Small Town Is Right for You?

Deciding what size town to move to is subjective. At the end of the day, only you know what town is right for you. Here are some jumping-off points to think about and questions to ask before landing anywhere new.

If you are thinking that you would like to live in a place that is very small—say, under 1,000 people—think about where the community stands from a moral and political standpoint. If your beliefs don't align with the majority of the town, it might not be the best fit for you. You might enjoy instead finding something on the outskirts of a larger town, where a variety of voices are represented—otherwise, you might feel isolated or stifled.

If you would like somewhere with a population of around 5,000 people, you might want to look at how you can bring something really special to the town. Or, at least, how you can participate in events already happening there. Think about how you can help grow the town in a positive way. I don't mean grow in size, because we also can't assume that a town wants to get bigger. Instead, how can you help the community expand in what they offer? How can you help the town flourish?

For towns of more than 10,000 people, the questions to ask are: *How can I find my community? What types of things can my child be involved in? Does this town have the amenities that I am seeking?*

Any town of over 15,000 is operating like a small city and should have the services to prove that. Your decision will likely come down to jobs available, location, climate, cost of living, proximity to interests such as nature, sporting or cultural events, and so on.

A small town between 20,000 and 25,000 will be similar. Look at the rate of growth for this size town as well. How fast a town is growing is an indication of how small it will feel and for how long.

How to Find Your Small Town

With so many small towns in the United States and Canada, how do you decide on just one place? It's the type of thing that could take someone a really long time to figure out.

Below are a few questions to ask yourself when you are looking for a new small town to call home. Really think about your answers. Consider what other questions could help you narrow down the location. Do you feel drawn to a mix of a few things when you think about relocating? What region can you envision yourself in? Think about what your priorities are. Do you want to be near water, but you also like the cold? Then maybe a beach town in the Pacific Northwest is for you. Do you want to live somewhere where you can wear shorts all the time, but love trying new restaurants? Maybe look for a small town in Florida that's near a larger city, where you can get out and explore new places of interest.

Choose Your Own Adventure

If you are seriously thinking about moving to a small town, keep these questions in mind as you read through this book. Below are just a few topics to start with. You will find so many more of your own that will hopefully narrow down your dream location in no time.

When you think about your dream surroundings, imagine what you are seeing:
> Mountains, beaches, ocean, forest, lakes or rivers, or a
> wide-open field?

Now do the same for the seasons:
> Would you like to experience all four seasons, only spring and fall,
> cold year-round, hot year-round, or a mild climate year-round?

What are your hobbies?
> Biking, hiking, organic gardening, cooking, arts and crafts, cultural
> events, live music, absolutely nothing, hosting outdoor dinner
> parties, or going to restaurants and bars with friends?

What's your clothing of choice?

> Shorts and a T-shirt, jeans and flannel button-up, dressed up, vintage, trendy, or athletic wear?

Where do you like to grocery shop?

> Local general store, big supermarkets, local store with organic food, chain organic stores, farmers markets, or do you need land to plant a garden?

What do you like to eat?

> Vegetarian? Plate lunch? Seafood? Meat and potatoes? Comfort food? Organic? Local selections of vegetables, meat, and dairy?

Get in touch with your senses:

> Do you want to hear nothing but the wind through the trees? Do you like a little noise from the community outside? Are you drawn to the sound of rushing water or waves crashing? Think about the sounds that you want to surround yourself with.

HOW TO LOCATE AN UP-AND-COMING SMALL TOWN

Ask a local real estate agent for a market update to see how prices have moved up or down in the place that you are interested in.

What types of local events do they have? Seek out the Main Street Association or Chamber of Commerce to learn if they pull the community together and, if so, in what way?

What is it near? A city? A college town? How is the growth in those places? Are people going to be pushed out and forced to expand to the town you have your eye on? How will that affect you wanting to live there? How will that affect property values?

Does the town have a lively Main Street or town square? What does local shopping look like?

How are the schools? Even if you don't plan to have children, this is an important question. It affects everyone when the schools are thriving or performing poorly.

Does the town support new business and growth? What incentives are there for new businesses to come to town?

Are there jobs for those in town who might be looking?

What are the health care resources? Do you have to travel out of town for basic needs?

Keeping Your Town Small

We move to small towns for many different reasons: because of their size, the cost of living, the community that they can provide. But what happens when the size of the town gets too big, the cost of living rises, or we no longer know our neighbors?

I've seen it often in various places I've lived, in both small towns and city neighborhoods alike. People move in and tell the locals what they are doing wrong or how they could do something better than they have previously. This is alienating and demeaning. How we approach our new towns is important, not only for the positive growth of the town, but also in how you're received by the locals. Many of the people who have lived there for their whole lives didn't ask to see their towns become larger or unrecognizable to them. This can create a fear in locals, which doesn't help anyone who is interested in cultivating a more culturally rich enclave. Keep this in mind as you embark on your new adventure of small town living. Look for ways to include the generation before you—the one that decided to stay there, raise their families there, and call it home for many years before you did. These same people helped create and preserve your small town selection—so they can't be doing it all wrong.

EAST

MIDWEST

SOUTH

WEST

IMANI BLACK

Oyster Farmer, Student, and Founder & CEO of Minorities in Aquaculture (MIA)

EASTON, MARYLAND

"We have a lot of information about the ecological changes over the last couple of decades, but not a lot of people have really looked into how ecological changes have affected the coastal communities that once relied on the resources that are fluctuating and depleting. I'm looking at the history and involvement of African Americans specifically in commercial fisheries. And I'm doing that over a fifty-year block, from right before the big crash in the Chesapeake Bay of oysters and crabs all the way up until present, to see a once prominent community that's now being impacted by gentrification in these historical locations, but also doesn't have a lot of involvement in commercial fisheries right now—how that perception and value and participation have changed and why that's changed. Is it because of the ecological changes or is it because of social changes and political changes?"

IMANI BLACK

Imani Black has lived on the Eastern Shore area of Maryland, in one place or another, her whole life. She feels such a pull to her home state's coastline and has such deep ties to the land and surrounding water that she's made it her life's work. As a student, Imani studies at the Center for Environmental Science in Cambridge, Maryland, a part of the University of Maryland, with a focus on ecological anthropology. She also founded Minorities in Aquaculture (MIA), a nonprofit focusing on educating minorities, specifically women, about the benefits of aquaculture in their communities.

FINDING GROWTH THROUGH THE STUDY OF GENTRIFICATION

"This [place] is what I'm familiar with, but also . . . my family has [history] here. And also, [there is] the history that the topic that I'm doing has here, on the Eastern Shore. It encompasses everything. In that [way], I'm doing a mini case study of gentrification. So I'm looking at Kent Island or Kent Narrows, Cambridge, and Bellevue. Those are the top three, historically prominent African American coastal communities that were really heavily involved in commercial fisheries that are now heavily gentrified," shared Imani.

Still looking to pinpoint the cause of, and find an answer to, the issue, Imani cites a domino effect that's been in motion for many years. As they were growing up, it was more or less instilled in her and her classmates that you graduate, you move on, and you move out. Left with fewer and fewer choices for work in the

area after graduation, most people took this path. Because of that, though, holes developed in the culture on the shore—holes once filled with generations of family aquacultural farms. Families with long-standing rights to the land and water are now faced with the decision to sell and move on, with no one left to carry on traditions. With only ten Black watermen on the Chesapeake Bay today, ranging in age from eighty-three to thirty-four, the once prominent culture is receding.

Through oral histories, Imani has learned that when African Americans started gaining increased access to higher education during the civil rights movement, more opportunities opened up outside of Maryland for the Black watermen. Whether you were a waterman, a sailboat maker, had your own seafood business, or worked for one, the climate began to shift. Suddenly, young Black people had choices that weren't there before. "That's what they'd tell their children: This is no longer a lucrative business. But also, I don't want you to have to go through the same labor-intensive job I did now that you have another opportunity to move forward and have a better education and do different things. Go and do that. Because that's going to be more of a career path or more of a life path than what we were used to," shared Imani, speaking about what she's learned. It's as a result of that mass exodus of generations of Black families that the land was sold off and the shift cemented.

By the time these long-held family lands had switched hands, living by the watersheds had become desirable. "Most, if not all, of the African American communities that are on the Chesapeake Bay were all by the water because waterfront at that time was not looked at as a high-society type of thing. They really pushed people of color by the water because that was like a poor man's chore," said Imani.

HOW TO BE AN ALLY AGAINST GENTRIFICATION

Support grassroots organizations that are working to be a voice for minorities in the town where you want to move.

Study zoning laws and develop an understanding of how these laws affect people of color where you are thinking of moving.

Understand what housing looks like in your town. When new people move in, where are those on a different socioeconomic level shifted to? Do they have to move out of town? Has the cost of living pushed them away? Is there affordable housing in the town?

Ask yourself, Does the Main Street in my town work to include people of color? Who are the businesses catering to? Are there incentives for people of color to open businesses? Are the services offered (restaurants, stores, coffee shops, etc.) places where everyone feels welcome?

Don't move to a place and begin to make demands of the town. Know the history before getting involved.

Know your local industry and understand how you can support the local farmers, businesses, etc. Keeping things community-based helps those businesses thrive and not shutter under the weight of growing overhead.

LOOK AT HOW YOUR COMMUNITY CAN INFLUENCE YOUR INTERESTS

"I definitely grew up wanting to do something in conservation and restoration—since I was really young. When you live in a coastal community, all of your activities are centered around being on the boat, fishing, crabbing, and other coastal activities. When I was growing up, I didn't really know what that history was, I didn't know about all the history of Black watermen. Turns out I have Black watermen in my family dating back all the way to the early 1800s," said Imani.

In her research, Imani found the historical record lacked information about minorities in aquaculture, as well as there being a

dearth of leadership roles for the community. From that, quite literally, her nonprofit MIA was born. "Active minority engagement is a lot more than a one-dimensional type of thing. It has a historical piece; it has a cultural piece that also goes into it. I'm using my knowledge and my thesis and the knowledge of people of color and coastal communities as an avenue to be like, 'No, I'm not bringing African Americans to a new table. We created this table,'" shared Imani.

UNDERSTANDING THE HISTORY OF A PLACE

"Living on the Eastern Shore is like [being in] an ever-changing relationship, but it's also super-familiar. It's my oldest friend, but we keep changing together. And I think the more that my perception of it changes, the more that my love for it starts to morph into different things. When I'm out in the water, that is probably my favorite thing to do in the entire

WHEN LOOKING FOR A NEW community to invest your time, energy, and space in, it is invaluable to understand the history of the place. Becoming part of a community is not just moving in and making the town your playground. It's a study of the land, and understanding how you can contribute to your new town without alienating or creating hurdles for someone else. That doesn't mean you can't move to a changing town, but it's important to recognize how to not become part of the problem for those there before you.

world, and I don't even have to do anything on the boat. Now I go to the water for answers and confirmation, because I understand the history. Now when I see that water, I see all of the people who came before me that look like me. All of these different things I see now when I look at the water that I didn't see before. As my knowledge and perception change, so does my love for it a little bit. Now when I get on the boat in the middle of the day, or look at a sunset, I'm like, 'Wow.' And to think of all of the people that rode on this bay before me, and what they had to go through so that I could sit here and appreciate this moment today; it's really huge for me. And it's really special," marveled Imani.

As she looks at what the Eastern Shore might need to continue educating people about the history of the Black watermen before her, she recognizes the lack of and need for school programs or a museum that represents the significance of the history of the people of the water. Looking to schools like the New York Harbor School, Imani hopes to see Maryland, as home to one of the largest estuaries in the world, create a maritime school of its own. "It would be really useful, because we've got to keep up with the traditional legacy and heritage here. People live on the water and don't have any relationship with it. And so, if we learned about some of those different things growing up or in school, then maybe there would be a trade sector for maritime occupations," said Imani.

EASTON, MARYLAND

POPULATION: a little over 17,000

CLOSEST INTERNATIONAL AIRPORT: 46 miles to Baltimore; 53 miles to Washington, D.C.; 89 miles to Philadelphia, Pennsylvania

CLOSEST LARGE CITY: 46 miles to Baltimore; 53 miles to Washington, D.C.; Annapolis, which is a large town at just over 40,000 people, is 42 miles away.

FESTIVALS NOT TO MISS: Sultana Downrigging Festival in October; Waterfowl Festival in November

Easton is almost 12 square miles in size. In comparison, San Francisco, California, is nearly 47 square miles.

Frederick Douglass, author and leader of the abolitionist movement, was born into enslavement in Easton.

Orchard Point Oyster Company has some of the best oysters to try.

Visit MIA at mianpo.org.

STU ELI AND JANET MORALES

Shop Owners of Three Potato Four and Merchandise Creators

MEDIA, PENNSYLVANIA

"We always said that if we had opened this business in New York, or I lived in New York, where you're surrounded by so much creativity and people making things, we probably would have been stifled thinking, like, 'Oh, it's already done, we can't make it,' but because we're in this bubble of this small town where there isn't a lot of that city trend, we're just like, 'Oh, let's just make it.' I think it's allowed us to be more free."

JANET MORALES

Husband and wife duo Stu Eli and Janet Morales are the creative force behind the internationally known brand Three Potato Four, now based in the small town of Media, Pennsylvania.

Janet grew up just outside of Washington, D.C. Stu was raised in northern New Jersey. They both found their way to school in Maryland, where the couple met. After college, they lived apart, with Stu in New York City, working for a book publisher, and Janet in D.C., working at a design firm, before she joined Stu in New York. Over time, both found themselves working for different design firms, eventually leading to the creative work they are doing today with their shop Three Potato Four.

They were living in a part of Brooklyn that required them to navigate the stairs of a three-story walk-up with an infant daughter in tow. They decided it was time to make some changes to the life they were living. Janet and Stu were looking to work for themselves and tossed around the idea of opening a hamburger stand and then a stationery store. Eventually, while living with Janet's parents outside of D.C., they arrived at the concept for Three Potato Four.

After that it was time to pick a place to drop their anchor. They pulled out a map and put a Venn diagram to work, ruling out places to move and narrowing their search down to Philadelphia. At the time, they were not thinking about any small, nearby towns. But after visiting a college friend they did just that, ending up in Media—just twenty-five minutes from the city, complete with a quaint Main

Street, a trolley that transports visitors and commuters to and from the town, and that community feel that Janet and Stu were craving for their family.

WHAT STAYING PUT MEANS FOR A COMMUNITY

Something that Janet and Stu noticed early on after they moved to Media was how welcoming the town was. "The people felt really real," shared Janet. Coming from a transitory area of D.C., where people were constantly cycling in and out, Janet and Stu were struck by how multigenerational Media was, with families staying after high school or children returning after college to put down roots and raise the next chapter of their family.

"It adds a lot to the culture here because people really care about the town," added Stu.

The value of having a town that creates a sense of community, where people want to stay for ten, twenty, or fifty years, is unmeasurable. It gives you time to see how you can add to your community while building the connections it takes to be successful with your ideas. It also gives you a place where you can feel safe, familiar, and full of the joy you might never find in a city, where you sometimes don't ever meet your neighbors.

HOW TO FIND YOUR OWN COMMUNITY

When Three Potato Four was just getting started, Stu and Janet primarily focused on hosting epic barn sales, where they sold vintage goods. Through their sales, they were able to bring together like-minded small business owners and artists to add to the sale, which aided the couple in finding the group of friends that they were seeking. By inviting other creatives to do pop-ups and collaborate on various projects, Janet and Stu were able to forge the creative community that they envisioned. They were all working for themselves, which meant that Janet and Stu had a lot in common with the other creatives they met in Media. The couple even started a small business group, for which they held meetings at their house.

From a business standpoint, before opening the Three Potato Four brick-and-mortar, Janet and Stu had a very healthy wholesale

business, with their creations heading out to over 1,000 shops around the world. Now, on a local level, they get to enjoy seeing their key chains on backpacks and their stickers on the backs of cars around Media.

RAISING KIDS IN A SMALL TOWN

Every parent has their own reasons for wanting to raise their children in a small town. But, at the same time, these parents also want to show their children the world. Janet and Stu are no different and have made a concerted effort to make sure their two children see past the Media town lines, regularly making trips to

IDEAS FOR CREATING YOUR OWN COMMUNITY

Organize art shows or art critiques in your living room, or work with a local business to host them.

Start a bird-watching club, or any other club that is of interest to you.

Host a freelance workers lunch or a regular coffee hour once a month.

Organize a street party or neighborhood yard sale to meet your neighbors. Invite local creatives to do a pop-up at the party or yard sale.

Send out an open call to young parents for a monthly playdate, organized by your child's age group.

Organize a local clothing swap, using a house of worship for space, and donate any leftover clothes to charity.

New York City—more often, even, than to their more local option of Philadelphia. It's always been important to Janet and Stu to take the time to travel with their children, encourage them to go out of state for college, and work against any fear of travel in larger places.

Living in a small town afforded Janet the ability to work a little less and be a more hands-on parent to their now teenage children. Part of what kept the family in Media were the bonds their children were making at school. "I feel like our kids rooted themselves here before Stu and I did," said Janet. The local pool, Hidden Hollow, a 1970s-style pool club with a giant snack bar, is where Janet and the kids spent their summers for their first few years as residents of Media. This allowed both Janet and the kids to strengthen their community and gave the kids a much needed outlet with their friends. They would also venture out to one of the many orchards around town, visit the shop Terrain, outside of Media, for a special lunch, and fish and catch tadpoles in the local pond—making nature a large part of their kids' childhood.

To provide a counterpoint to the lack of diversity in Media, Janet has brought her Filipino heritage into their home when their children have friends over—introducing them in the best way possible, through food. Offering the kids Filipino snacks further acquaints them to the world around them.

WAYS TO INTRODUCE THE WORLD TO YOUR CHILDREN WITHOUT EVER LEAVING TOWN

Have an international supper club, inviting other families over to taste food from around the world.

Host an outdoor movie night, setting up a screen on the side of your home and showing an international favorite family film.

Support restaurants in town that might be serving food you aren't used to trying.

Try to grow a fruit or vegetable appropriate to your growing zone that also grows in another part of the world, for example jackfruit, watercress, or snow peas.

Look for cultural events, such as a Greek Festival or Indian Night, at the local university. Anything that your town or area offers that would introduce your family to more diversity is always a plus.

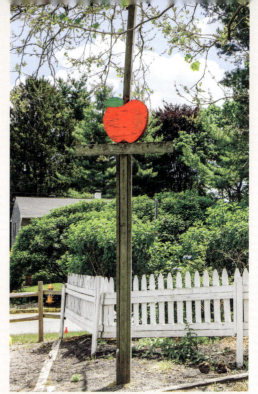

MEDIA, PENNSYLVANIA

POPULATION: a little over 5,900

CLOSEST INTERNATIONAL AIRPORT: 11 miles to Philadelphia; 23 miles to Wilmington, Delaware

CLOSEST LARGE CITY: 18 miles to Wilmington, Delaware; 22 miles to Philadelphia

Media is a small town, yet it has a charming streetcar trolley system offering public transportation.

Wanda Sykes calls Media home.

In 2006, Media became the first Fair Trade Town in the United States, meaning that it adheres to a higher standard to make sure that workers and farmers receive a fair price for goods produced and sold, as well as the work that they do.

Media is home to Tyler Arboretum, a 650-acre park full of trails, an arboretum, and tree houses.

Visit Janet and Stu's shop at threepotatofour.com.

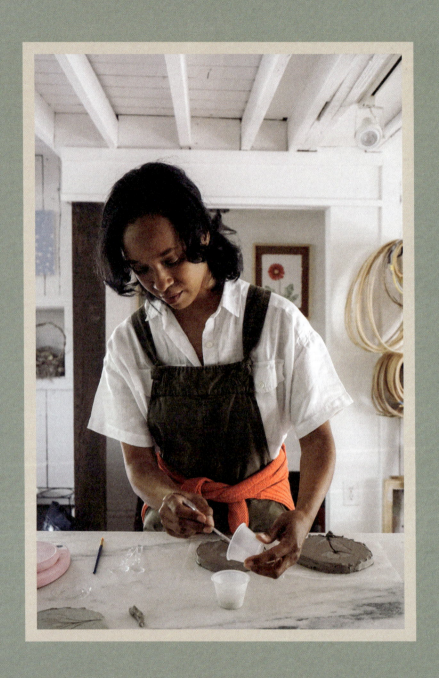

RONNI NICOLE

Artist

NEW HOPE, PENNSYLVANIA,
AND LAMBERTVILLE, NEW JERSEY

"I always believe landlords don't really bring to the community, they take away from it. They're not going to really invest in the property the way you would your home. So the more homeowners you have living in the homes, the better the community is going to look. We want to buy something here. We're saving up. We're gonna do everything we can to buy a building here in New Hope, maybe on Main Street, so that we can put something here and have it be ours. I think the only way to, like, really create that kind of change is to buy."

RONNI NICOLE

Artist Ronni Nicole has a unique small town story. She lives on the border of Pennsylvania in Lambertville, New Jersey, but crosses the Delaware River just to the west on a daily basis to go to her studio in New Hope, Pennsylvania, where she has based her thriving fine art career.

Her goal for the town where she works is to help diversify some of the local boards, like that of the arts council. She's also committed to being in her studio daily, adding to the community of working artists in New Hope. She has a plan to invite as many people as possible to town, encouraging them to open businesses in New Hope, live in the town, and work to create the community that she visualizes as she simultaneously navigates the potential of what it can become.

FROM CITY TO SMALL TOWN TO CITY TO SMALL TOWN

Ronni and her husband David are both from Philadelphia and grew up surrounded by the city. By the time the two started dating, they were both longing for something slower. They leaned into seasonal life, spending their summers working on Martha's Vineyard and winters working in Park City, Utah. "That's when that urge for small town living began. That's when it hit. Once you do it, it is very hard to go back," shared Ronni. And they did try to go back to the city. For seven years they lived in Philadelphia, but the grind got under their skin and made them realize that they weren't built for city living anymore.

While living on Martha's Vineyard, Ronni got used to the small town way of life—one

in which you have full conversations with strangers all the time. For those who have lived in a small town for a while, this is commonplace, but when you are new to small town living, it can catch you off guard. "Once I got used to it [small town conversations] and I settled into it, it was really hard to exist without it," shared Ronni. During those seven years back in the city, Ronni fought the urge to talk with people on a regular basis. People in the city have deadlines and places to be. There is such urgency, such hustle, that you don't have time to stop and just chat and get to know your neighbors. This is something that Ronni and David found they really wanted from their small town community.

SCRATCHING THE SURFACE

When a town depends on its tourists and serves those tourists well, does it still leave room for the people who live in the town? Is there enough energy and space left for those who call it home year-round? In New Hope, Ronni knows that there's a way to offer more for residents who want it.

Prior to moving to Lambertville and setting up the studio in New Hope, Ronni and David were tourists in the area themselves. They were charmed by the towns and the beautiful river that runs between the two states. Once they moved to the area, however, it was more evident that services were lacking for the residents. Over the years, and as more and more

people move to the area, places to shop—like clothing boutiques and home goods shops—will open, but it all takes time. Slow growth is an important key to long-lasting progress.

Shops like The Meaning of Things in New Hope, which offers items that cater to the locals, are certainly a step in the right direction.

There's also a market hall, New Hope Ferry Market, which you don't see in many small towns. This establishment serves many different types of food options in a much smaller setting. Ideas like this are perfect for a small town, because eventually some of those restaurants can transition into larger spaces, leaving

SERVICES THAT SUPPORT LOCALS AND TOURISTS

- Arcade with vintage video games
- Art galleries
- Bakery
- Bar
- Bed-and-breakfast with a cute breakfast restaurant attached for nonguests
- Bike rentals
- Bookstore
- Chocolate and candy store
- Clothing boutique or small department store
- Coffee shop
- Community pool
- Farmers market
- Flower shop
- Food truck
- Gift shop that also has elevated specialized town merchandise for the tourists
- Grocery store with local food provisions that tourists can bring home to their family and friends

- Hair salon
- Ice cream shop
- Local theater for plays
- Locally curated goods store
- Microbrewery
- Music, movies, and/or theater in the park
- One-screen movie theater
- Organic skincare and cosmetics store
- Outdoor group activities like bocce ball courts, horseshoe pits, shuffleboard club, pickleball
- Pharmacy
- Record store
- Restaurants
- Stationery shop
- Thrift shop that benefits a local charity
- Toy store
- Vintage store
- Yoga studio

room for other restaurants to move in and try their hand at bringing their food to the market.

When you create businesses for locals and tourists alike, you are keeping those tax dollars inside your own economy, making a better community for yourself and everyone else who lives there. Ronni has leaned into keeping her money local by using all local flowers in her artwork. Moving forward, she plans to create collections based on what they are growing seasonally, with the hope of generating more awareness for the local CSA that she and David are a part of.

For artists, another aspect of catering to the tourists and not the community is locking yourself into a more limited price bracket and style divorced from your local surroundings. Instead, try to cater to the people who live in your town as well, creating artwork that can be developed, styled, and influenced based on local tastes and traditions, rather than for people who might not ever return.

WHEN YOU CAN LIVE ANYWHERE AND STILL THRIVE

Ronni has established a business that can operate from anywhere she would like to be—one that allows her space to just create—because of the online community she's built around her endeavors. While she and David lived on a farm during the pandemic, Ronni made a dream list of places to call home, not knowing that her dreams would become reality. New Hope was on that list, and after applying for a grant with the local arts council, the studio was hers.

"Life happens, so we allow life to be part of our business," said Ronni when talking about her day-to-day work schedule. She doesn't make a point to get to the studio by 9 a.m., but she works every day on her own schedule. On the flip side, though, New Hope is full of working artists, and Ronni loves that people can see her working in her studio just off the main road through town. It's important that people see artists working, especially when the cost of living is rising everywhere.

People can relate to artists as workers in such instances. People can also picture themselves in those moments, and visualize themselves in a space, creating. Artists bring so much vibrancy, longevity, and culture to town, so celebrating them—and the possibility to join them—should be revered.

Ronni has never been quiet about her beliefs and her political positions. Some people might not want to rock the boat, but it's equally important to let those in office know that their constituents might not support the same things they do. This is how you bring change to a community, by showing that you have a different voice or a different outlook than others around you. It can be scary to speak up and speak out, but conforming does not bring the change you may want to see in your communities.

While New Hope has more artists, Lambertville has more art galleries, including two Black-owned galleries—which creates a fully working two-town, two-state symbiosis. "I'm going to have to keep saying out loud to people that we want artists here. This is what brings people into the town. People like seeing artists. So let's bring artists here and make it affordable," affirmed Ronni.

NEW HOPE, PENNSYLVANIA, AND LAMBERTVILLE, NEW JERSEY

POPULATION OF NEW HOPE, PENNSYLVANIA: a little over 2,600

POPULATION OF LAMBERTVILLE, NEW JERSEY: a little over 4,100

CLOSEST INTERNATIONAL AIRPORT: 49 miles to Philadelphia, Pennsylvania; 60 miles to Newark, New Jersey

CLOSEST LARGE CITY: 31 miles to Philadelphia

Andy Warhol once lived in New Hope, and just across the river, Lambertville is a haven for artists of all mediums.

Nina Simone used to perform in New Hope in the 1950s and '60s.

There's always been a lot of counterculture in both New Hope and Lambertville.

Learn more about Ronni's work at ronnicole.com.

BRI EMERY

Creator of the Blog *Design Love Fest*

POUND RIDGE, NEW YORK

"When we do go to the city, it's really energizing, but when you come back, you can just feel it melting off and you instantly feel way calmer. I just think my nervous system was also a huge catalyst for the move. I was going through the healing process in multiple ways, and the speed of this place, it's so good for your body."

BRI EMERY

Bri Emery, creator of the blog *Design Love Fest*, never imagined that a house swap from Los Angeles, California, to Shelter Island, New York, would lead to a full-on coast-to-coast move for her and her husband Justin. In the winter of 2020, after losing her dearest friend, she was looking for a change, a rejuvenation from the sadness that surrounded her. Seeking out a new environment and a place with seasons led them to the East Coast and their new home of Pound Ridge, New York, close to the Connecticut border. "I forgot what seasons even felt like," Bri shared.

ANSWERING THE SIGNS

As Bri and Justin were leaving Shelter Island and starting the drive back to California, they stopped to visit two friends who had recently moved to the area. As they were sitting there at lunch at a restaurant called Purdy's Farmer and the Fish, both were overwhelmed with the feeling that they had found where they were supposed to be. "We started our hunt then [for a house,] and six months later, an opportunity came and we decided to go for it," shared Bri.

While Justin bounced around to a new city each year before meeting Bri—including Portland, San Francisco, New Orleans, Denver, New York, and Los Angeles—Bri was another story; she was busy creating a community around herself in Los Angeles. After sixteen years and the loss of her friend, though, she was looking to start fresh, surrounded by nature. "I felt like the way that the house swap happened was so serendipitous and the way we found this house was also so serendipitous

more work done from home, so his need to be on-site dwindled and the relocation became feasible. In Los Angeles, Bri had been working from home for years, so their new normal found them on top of one another. But in their new home, each has the space to spread out and have their own designated workspaces and styles. "He loves noise and music, and I love silence and the alone time to think. So it's been really nice to have that separation here," said Bri.

After a two-year work sabbatical, and with the new inspiring space she found herself calling home, Bri discovered a new vision and direction to take her work. "You really have to give it a lot of space to unfold. Ask yourself where you *actually* want to go, not because you have to or because you have to keep up with this thing. What do you actually want to do next? The time I've given myself in nature, it's starting to unfold," said Bri.

When moving into a new home, you want to see where the light falls before selecting paint colors to find out what looks the most natural. It's the same for uprooting yourself and making life changes. Allowing your mind to rest and explore what feels the most natural follows a similar pattern. So often, we rush from one thing to the next, even when slowing down and taking the time to really listen to our bodies are what we should be focused on. "As this new path starts to unfold, you see that it's exactly what you thought before, but

that I just felt like the universe was pushing me here and I was just blindly following it," said Bri.

When the pandemic began, Justin, a freelance animator, wasn't sure what the day-to-day would look like for his business. He had previously moved from studio to studio for different projects and was now working from home like the rest of the world. Over time, as the restrictions lifted, everyone in his field began to realize they could actually get a lot

and we thought that we would go more, but once you are home, you don't really want to leave. When we do go to the city, it's really energizing, but when you come back, you can just feel it melting off and you instantly feel way calmer. I just think my nervous system was also a huge catalyst for the move. I was going through the healing process in multiple ways, and the speed of this place, it's so good for your body," remarked Bri.

In the city, you don't even realize how fast you are moving or process the noise pollution that you are hearing. Sounds jar you multiple times a day, while signs jump out of the landscape at every turn, reminding you to buy something or that humans were here. "Your body does adapt to city living, but it's kind of scary, because you can adapt to something that's really not that great," added Bri.

FINDING THE CALM AND PEACE

With such a big change—going from a place with a population of 3.849 million to one with just 5,153—Bri quickly discovered that she's not as extroverted as she once thought. Now, she is really focusing on the quality of a few friends with whom she is able to make more meaningful connections. When you live in a city, you feel the pull to go out all the time and bounce from event to event, so the fear of missing out becomes a real thing. With the pace of a small town, you are able to take a moment and really decide with intention what

different and still magical and exciting. I'm so thankful that I listened to myself and followed this because it's really scary to feel like I am giving up this big career that I built that was fun and exciting, but LA just wasn't what it was anymore for me," explained Bri.

Bri and Justin did have a checklist—or "a feeling" as Bri called it—for the area they decided on. They wanted to be a short train ride to the city and close to nature. They also wanted a home with a 1970s vibe and a cabin feeling. Natural light was equally important. "We are one hour by train to New York City,

you want to invest your time in and how you want your energy guided, so you can find more calm and peace.

LIVING WITHIN YOUR NEEDS

When you take a step back and see that you just have several restaurant options, a hardware store, a farmers market, a grocery store, a gas station, and a few shops, you realize that while, yes, it's small, you don't really need more than those things. "I do have a friend who is a local ceramist who I have breakfast with every Thursday, and we go to the John Jay Farm Market each week, but we are still homebodies," shared Bri. Finding your needs is part of living in a small town. Ask yourself: *Does this town I'm looking for have all that I need? Is what I think it might be lacking more of a want? And can I get those wants when I travel to the nearby city to the point that I feel satiated?*

FINDING YOUR COMMUNITY

Finding your people, your new friends, and your community looks different for everyone, but for Bri, doing so provided the perfect pace that she needed during her transition. Connecting with like-minded artists in town left

her feeling very connected quickly. "There's a woman's workspace, much like the concept of WeWork. I went to a few events there that led me to meeting photographers, artists, and stylists, who would remark, 'Oh you have to meet this person' and we will all go out to dinner together. I felt welcomed right away, but like low pressure. Everyone's at such a slow speed that it's like, 'I'll see you in a month or so.' And you're like, 'Perfect,'" shared Bri. Making sure that your new community works at the pace that you need is important for a healthy live-work balance in a small town.

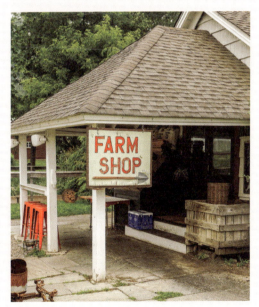

PLACES TO LOOK FOR COMMUNITY

Community centers	Local food pantry volunteering
Farmers markets	Local restaurants or grocery stores
Local coffee shops	

FINDING YOUR NEXT CHAPTER

With the move came a realization that the career path Bri had been on was no longer the path that she saw for herself. It was time for a change. She's slowly beginning to find her direction, but teaching continues to work itself into her practice. Working with children and friends alike, she's finding healing through the knowledge that she can share. By leaving the city behind, she's affording herself time to slowly navigate what that looks like, creating a field that she can approach in the time that works for her—one that is more meaningful to her than anything she's done previously.

CONNECTING MORE AS A FAMILY

Moving across the country connected Bri and Justin in a way she didn't expect. "It made us feel more like a family. He moved into my house in LA, so it never really felt like *ours*. Where this definitely feels like ours. We are changing so much as people, so it was so much

adjusting, but now we feel so much closer," shared Bri. There's seemingly something magical about the ability to explore a new place and find a town to move to with your loved ones, connecting you in ways that you haven't had previously.

A FEW QUESTIONS TO ASK YOURSELF

What does the next chapter look like for me? What am I hoping to gain from the experience? How can this new direction serve me and my community in a more positive way? What will I bring to my community with this new shift? Who is this next chapter for? Am I okay with the shift of what my business might look like in the new environment?

POUND RIDGE, NEW YORK

POPULATION: a little over 5,000

CLOSEST INTERNATIONAL AIRPORT: 34 miles to New York LaGuardia; 41 miles to New York JFK

CLOSEST LARGE CITY: 12 miles to Stamford, Connecticut; 51 miles to New York City

Pound Ridge is almost 30 square miles of mostly undeveloped space.

You can find Bri at @designlovefest on Instagram.

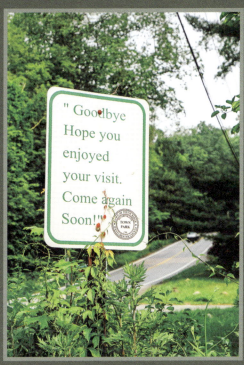

" Goodbye
Hope you
enjoyed
your visit.
Come again
Soon!!"

DO-HEE KIM

Graphic Designer and Farm Owner

ATHENS, NEW YORK

"One thing I love most about small town living and the most surprising thing is talking to strangers. And just meeting people, and spending time with people in a way you just don't do in the city. It's kind of rude in the city to take someone's time for forty-five minutes to talk to them. But here, that's literally what we do. You know, you run into someone and you end up hearing their life story. I love engaging with people in a very different way than you would in the city."

DO-HEE KIM

Do-Hee Kim took a long, beautiful path to get to where she and her husband Josh are now—renovating their forever home in Athens, New York, a small hamlet that sits along the Hudson River. Before Athens, Do-Hee lived in San Francisco; Gainesville, Florida; and Seoul, South Korea, where she was born. Josh grew up in Brooklyn. They moved back to his home state after the couple's ten years in California. The two knew that they would end up making their way back to the East Coast at some point, to be closer to family and because they had an itch to start a farm that they couldn't shake. When they found an 1885 Queen Anne–style Victorian farmhouse residence on the market that checked every box, the couple packed up and made the pilgrimage back east.

A DIFFERENT VERSION OF COMMUNITY

"I've talked to more of our neighbors or people in town and spent more time talking to them than I have in all of my years in San Francisco combined. I liked our neighbors in San Francisco. But we were not standing there talking for forty-five minutes. But here, it's the norm. You just talk to strangers—which is scary, but it's also really nice," said Do-Hee. Small town living has that effect on people. You talk to strangers on the street, at the mailbox, in the grocery store. Time has a way of spinning differently, and with less pressure comes the room to get to know one another a little more, pause longer, and sit with those snippets of conversation a little longer, too. "I think when you live in the city, there's a certain amount of detachment. You don't really need to know

how things work. You can kind of live your own life, but here, you know, in order to do something or get something done, you have to kind of know how everything works or go talk to the right person. But they're your neighbor. So learning how everything works, versus in the city, I just wasn't even aware of that at all," marveled Do-Hee.

A FAR-OFF FANTASY BECOMES A REALITY

"We knew we wanted to move out to the country. And my husband really wanted to grow vegetables and farm for a long time. We knew we needed land. Neither of us really knew anything about anything. It was just a fantasy we had," remarked Do-Hee. Setting out to find the right location came next. The couple first explored New Jersey and Pennsylvania, but neither gave them the feel they were looking for. Having access to New York City was important for Josh's family ties and Do-Hee's career. They slowly worked their way up into the Hudson Valley. After searching for a while, the couple found an old house that needed some work, but wasn't a full renovation, with ten acres to farm on the property, but it was still within walking distance of downtown Athens. "There's no store in town that sells produce. We're doing small-scale organic farming. We have your usual vegetables, but we want to also include Asian vegetables," shared Do-Hee. Josh and Do-Hee also started a farm stand at the end of their driveway.

Finding community through other farmers in the region has been special to Josh and Do-Hee as they navigate this lifestyle change and branch out to explore other enclaves in the area.

Aside from farming, Do-Hee's vision is bringing a creative culture to their land through hosting workshops and community events, while Josh wants to turn the barn into a ceramics studio. "We really want our home and space to be a place for beyond just us. And I think that's been on our radar a long time, even when we were in San Francisco," expressed Do-Hee.

RECOGNIZING TOWN DIVIDE

One of the biggest issues that someone might face when moving to a small town is the pushback from those who have spent their whole lives there. Fear of people moving in and changing things can cause a lot of stress and divide those seen as new residents and those seen as locals or people who grew up in the town. How you invest in your new town also plays a role in how you'll be perceived. And places can be further split if there are many people who live part of the year elsewhere. "Full-time really means you're investing in the town's economy and supporting that year-round versus just during the summer when everything is busy," added Do-Hee.

COUNTRY VS. CITY COST OF LIVING

"People always talk about how city living is so expensive, but we've just learned how expensive it can also be living out in the country—especially dealing with weather. In the city, everything was taken care of. You just paid your rent or your mortgage. But here, a tree falls down or we need to get our snow removed from the driveway, just all those things you don't think about. Country life is very expensive. There's so much cost we never could have imagined. In the city, it just never crosses your mind," said Do-Hee.

Much like Diane Keaton in the wonderful 1980s film *Baby Boom*, who also learned escaping the city was exactly the sort of thing she had been looking for, Do-Hee quickly realized that costs for well water and heating oil were things she'd never had to explore before. Neither were major home repairs, like when the weight of a long snow was causing her roof to collapse.

HOW A CHANGE IN ENVIRONMENT CAN INSPIRE YOU IN DIFFERENT WAYS

When you live in a city, sometimes just getting out onto the sidewalk and taking a stroll around the neighborhood can invigorate your creative process. What does that look like when you have moved to a rural environment and maybe can't connect with your surroundings so easily? For Do-Hee, she's simply shifted what inspires her. "It actually makes me find inspiration in other ways—like through nature. And while I don't leave our grounds, I can just

step outside and I'm in a beautiful setting. And we have seasons here, which is crazy, because in California we don't have seasons. I think I'm just being stimulated in a different way. I don't know if it directly impacts my creative process. In some ways, it makes me pay attention more to the things around me. Because again, there are no seasons in California, there's nothing unexpected that comes up, but here, it's like every day, there's something new, for better or for worse. And I feel like it forces me to think a little differently and pay attention to different things. And in other ways, I think it forces me to seek out stimulation or engagement, [and] changes the way I think or what I'm paying attention to," said Do-Hee.

COST OF LIVING FACTORS

A few factors to consider, beyond weather, that might add to your cost of living are:

How much will you pay for shipping goods that you can't find locally or traveling to get the items?

What might your new property taxes be, as they vary state to state, town to town?

When it comes to children, will public school be right for your family or will you need to pay for private school?

What are the costs of after-school activities or childcare?

How does the cost of food in a small town, where many items have to be imported, compare to a city where the costs are sometimes lower?

Is your water on the city line or well?

Do you have a septic tank that will need to be emptied from time to time?

Is there trash pickup or do you have to haul everything to the dump yourself?

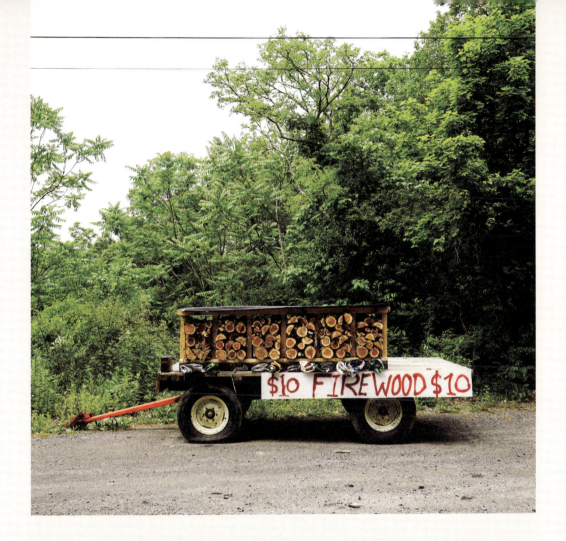

ATHENS, NEW YORK

POPULATION: almost 4,000

CLOSEST INTERNATIONAL AIRPORT: 40 miles to Albany

CLOSEST LARGE CITY: 107 miles to Newark, New Jersey, and New York City

Athens sits right on the Hudson River and is just across from the bustling small town of Hudson.

The charming landmark of the Hudson-Athens Lighthouse was built in 1874.

You can find Do-Hee and Josh at @vernonstreetfarm / @shoppetheory / @schmohee on Instagram.

LINDSEY WEIDHORN

TV Show Executive Producer, Founder of 547 Barnard

CAIRO, NEW YORK

"By the time I was leaving the city, I was so lonely. I had a boyfriend; a million friends; I had the dream job—I had everything you'd want. But I was so lonely. Feeling alone in a city that's full of people is the most depressing thing in the world. New York City can become whatever you want it to become. That's kind of the beauty of it. And I think that I was just at this stage in my life where I didn't have the energy that New York City requires of you, to bring it into the next phase of my life. I haven't had a single moment of a lonely feeling in Cairo, even when I'm alone. I climbed to the top of Kilimanjaro just to find something, anything. I was climbing the top of every tall mountain, and I was driving across the country. I was doing all these things to find something, and now I'm not looking anymore."

LINDSEY WEIDHORN

On the South Shore of Long Island, New York, just fifteen miles from New York City, Lindsey Weidhorn grew up in a house that would shake when airplanes took off from nearby JFK. Living as if she were in a fishbowl, Lindsey was able to see into all of her neighbors' windows and vice versa. It was all she knew, and she didn't think anything of it growing up. "It was a very loud upbringing, but we didn't realize just how loud it was," shared Lindsey.

After college, first in Syracuse and then at New York University, Lindsey moved to Salt Lake City for a year to work for the Sundance Film Festival. The loss of a dear friend brought her back to her home state and to New York City proper for the next fourteen years.

THE AHA MOMENT

As a TV producer, Lindsey had worked all over the country, but it wasn't until she was shooting the premiere episode for *Fixer Upper* with Joanna and Chip Gaines, a show she had a big part in creating, that she had her breakthrough. "I was standing in a field by a bunch of cows. And I said to them—and I remember exactly what I said—'You're doing it right and we're doing it wrong.' They had all this space to create the world that they wanted to live in," shared Lindsey, reflecting on their life in a small town versus her life in a city. Lindsey describes living in New York City as her gilded cage: it was a place that didn't give her the freedom she was seeking, even though it offered all the opportunities in the world. She recalls thinking that she couldn't just pick up and

move to a small town in Texas. What would that look like for a thirty-something, single, Jewish woman?

With Chip and Joanna, Lindsey learned what it's like to have land and live off the land. With Ben and Erin Napier, hosts of another show Lindsey created called *Home Town*, Lindsey was able to see what living in a small town was like and was able to make a distinction between the two. She started to recognize that she wasn't getting the feeling she was seeking living in New York City. What pushed her to finally find her new life in a small town was a conversation with Chloe MacKintosh, the founder of interior design firm Boxwood Ave. Chloe had made the move from Reno, Nevada, to Likely, California, population 99, and she told Lindsey that after getting out of the city she just felt content. That became the bar that

Lindsey set for herself: the next place she moved to would have to leave her feeling content.

The plan was to have both: to keep her New York City apartment and find a small place in New York's Hudson Valley. She would fix up a property to run a bed-and-breakfast in the Hudson Valley and return to the city during the week. Once she found her twenty-nine-acre property in Cairo, though, the idea of keeping her residence in the city was gone. She had found her contentment.

A VALLEY OF SMALL TOWNS

Cairo is often called the Crossroads of the Catskills, as it is a hub town of sorts. It spits you off in several directions, landing you in another small town no matter which way you drive.

BONUS TOWN PAIRINGS AROUND THE COUNTRY

Bay St. Louis, Mississippi, paired with Pass Christian, Mississippi

Brevard, North Carolina, paired with Hendersonville, North Carolina

Cairo, New York, paired with Leeds, Catskill, and Windham, New York

Sequim, Washington, paired with Port Angeles and Port Townsend, Washington

Stinson Beach, California, paired with Mill Valley and Bolinas, California

Tarpon Springs, Florida, paired with New Port Richey, Florida

Warren, Maine, paired with Camden and Rockland, Maine

Westerly, Rhode Island, paired with Watch Hill, Rhode Island, and Mystic, Connecticut

Whitefish, Montana, paired with Columbia Falls, Montana

One thing to understand about a small town, no matter which you choose, is that you will be branching out and using other nearby towns as an extension of where you live. You might head twenty minutes in one direction to go to the movies or the bank. Maybe the next town over has the only bakery around and you really love their fresh bread.

It's one of the beautiful things you will experience when you live in a small town—you get a bonus community just one town over. It's about adopting the mentality that we are all in this together and that the other community will also come to you for services as well.

You can see the same concept play out on a larger scale in places like Berkeley to San Francisco or Brooklyn to Manhattan. These communities are separate, but like a beehive, work together to form a larger community and scale of services for the people who live there. Small towns are like that, but in a much quieter and slower-paced way.

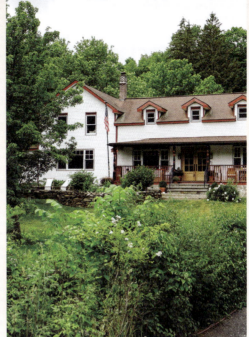

CREATING A COMMUNITY FOR YOURSELF

Friends and family are everything to Lindsey, and having them nearby is incredibly important to her. When she found her home, it was at the top of her list to create a place where people could come and go—that her home was their home and no one ever had to ask to visit. Her motto was that she'd find room for them, and it's with that warmth and welcome that she's created the exact community she'd been searching for in the city all along.

With the twenty-nine acres, Lindsey has been able to create what could best be described as the apartment from *Big* meets *Silver Spoons*: a fun-for-all-ages retreat that she gets to call home every day of the year. With everything from an in-ground pool and trampoline to a bocce ball court and archery range, from a hammock under the trees to a pool table in the middle of her living room, there's a little something for anyone who stops by to visit—making them feel right at home. And they're guaranteed to have fun while they're there.

YOU WILL WANT TO CHOOSE YOUR realtor pretty carefully, because they could be your gateway to friends and a community. Your realtor is connected to a lot of different things. If you want to play golf, for example, it's their job to show you the part of the community that will facilitate your hobby. Make sure to find someone who's going to point out the things in the town that are on your checklist. It's not just about the house at the end of the day.

BLENDING THE OLD AND THE NEW

Because of Lindsey's line of work, she's watched the inner workings of towns and cities across the country. She's seen what works and what doesn't, and at the core of all of it, she's found that welcoming new people is the most important aspect of a town's success. "If there's one thing I've learned from watching towns grow and change over the years, it is that the way to actually make your town go and create positive change is to welcome new people to town," said Lindsey. When you show you are open to new people, new businesses, and new ideas, you are welcoming tax dollars that can improve the schools, the roads, and the general quality of life for everyone. If you're closed off to change and newness, your town and the people who call it home will suffer. Newness doesn't mean getting rid of the old. "Look at what Erin and Ben [Napier] did for Laurel, Mississippi. They're not getting rid of the old in their town; I think they're really honoring it," remarked Lindsey. Working to bring in new businesses, diversity, and young families can only make your town a more enjoyable place for everyone.

Together with a friend and fellow small business owner, Lindsey has plans to open an antiques shop on the Main Street of Cairo. Blending her love for interior design and the vision for set design that she's never really been able to turn off, her store is certainly a step in the right direction for the community of Cairo, where small businesses are needed. "There is a clear line between, like, if you're putting it into your community, you're getting it back for yourself," shared Lindsey.

PEOPLE WHO HAVE BEEN LIVING IN small towns for most of their lives and the people moving to small towns now often don't realize they have the same end goal: a happy, healthy place for kids to grow up in; enough jobs and enough money; and a good community. There's so much to go around, and we could all be sharing and creating something closer to a utopian society rather than a dystopian one. New restaurants and shops don't mean that your town is going to change and not be a small town anymore. They just mean that it's going to offer more: more jobs, more tax dollars, more diversity. It's important to ask the questions: Why do you not want your town to be better? Why do you not want the schools to be better?

CAIRO, NEW YORK

POPULATION: a little over 1,350

CLOSEST INTERNATIONAL AIRPORT: 39 miles to Albany

CLOSEST LARGE CITY: 38 miles to Albany; 125 miles to New York City

The median income for a household is $28,478, and the median income for a family is $34,063 in 2023.

The bonus town of Catskill, just nine miles away, is where the story of Rip Van Winkle was penned by Washington Irving and was also home to painter Thomas Cole.

You can find Lindsey at @lindseyweidhorn on Instagram.

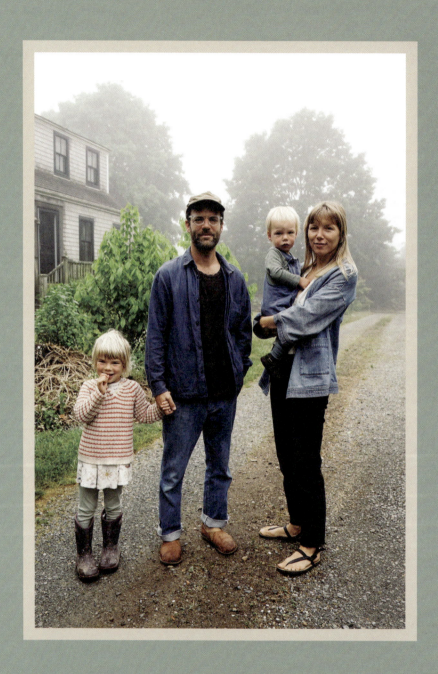

SEAN SPELLMAN AND MY LARSDOTTER

Artist, Designer, Musicians in Quiet Life and My Bubba,
and Innkeepers

WESTERLY, RHODE ISLAND

"I've really been motivated to be in a place where I felt like I could create some positive change. I like the ability to create community and do projects. I had an incredible studio in Westerly [before I moved to my home studio]; it would have cost me four grand a month in any city. Landing in a place after playing music for so long, having no savings, no money, and being able to establish myself there—that's why people move out of cities, right? And that's because there's more opportunity for that and that's what it provided us, but the sacrifice was the lack of community you know, like a creative community and like-minded people. But the ability to create that here is something I've become really passionate about."

SEAN SPELLMAN

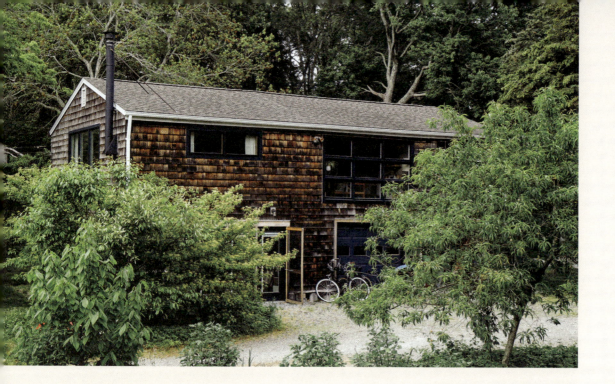

Sean Spellman and My Larsdotter both spent years touring the country, crisscrossing the United States, visiting cities, small towns, back roads, and everything in between. It was a chance meeting when both of their bands were part of the same festival that brought the two together.

Sean grew up on the East Coast, moving from New Jersey to Connecticut and starting college in New York City before relocating to California. Always a bit of a wanderer, he started in Newport Beach and drove up the coast to see where he might want to settle down with no real commitments at the age of twenty-two. When his band Quiet Life followed him to California, they lived in San Luis Obispo for a bit, then moved down to Los Angeles before making their way out of California and up to Portland, Oregon, in the early 2000s.

It was during his six years in Portland that Sean saw how a creative community could function. Portland was still a small city at the time, and the explosion of the internet hadn't yet shaped it into the city it is today. He saw creatives working together, bands supported by their community, and restaurants with space to develop without a lot of overhead. Sean realized as his time in the city was coming to an end that he wanted to take that same energy to a new place, a smaller place, one that still felt like it had aspects of his creative lifestyle that he could help to form, rather than riding on the coattails of others.

While he was looking for that place, in between touring, he lived for some time in

San Francisco, where he and My met, before they returned to Los Angeles for a short stint. Eventually, Sean and My made their way to Westerly, Rhode Island, which reminded My of where she grew up in Sweden. The couple initially planned to just spend the winter there while figuring out where they wanted to live next. They found a winter rental and lived on the beach, feet from the ocean, and have been in the small town ever since. Now they are raising their two children and have a thriving art, creative consulting, and short-term rental business.

WORKING TOWARD CREATING A DIY CREATIVE COMMUNITY

The opportunity to bring a creative vision to life inspires Sean. After his days in a touring band and his part in the underground DIY music scene, Sean realized that you don't have to have a cool gallery or amazing music venue to bring together a creative community. That community can quite literally be happening in someone's garage or a coffee shop or the spare room of a restaurant. Even renting your local VFW hall for concerts—to lean into the music scene of the 1990s—is an idea.

"What I want to do is open a place—a hotel, café, whatever—where people are coming in and where bands form out of it, where art is made because of conversations and ideas are just thriving because you're getting these people together. And they're just motivating and inspiring each other. It's such a simple concept," shared Sean.

Taking cues from all the unique places his band played over its years of touring, Sean is working to bringing all of that energy to Westerly. Sean also leans on ideas that have proven to be successful—for example, Folk Steady in the Ojai Rancho Inn, where a full creative community was formed from music under the trees. This recurring event brought people to the area who might not have otherwise had Ojai on their radar. Sean sees the merit in thinking outside the box and creating events for the town in creative ways in places that already exist—making it great for all of those involved, including the business owners who might otherwise not have the creative economy income.

WAYS TO CREATE AN INCLUSIVE CREATIVE COMMUNITY ENVIRONMENT FOR LOCALS AND NEWCOMERS

Work with older, established businesses to realize your vision and create together.

Listen to what the town wants or needs in the creative sphere.

Look for the hubs in town. If that's a local gas station that doubles as the morning breakfast spot, talk about hosting a pop-up with a young chef who is doing something outside the box. If it's a coffee shop, see if you can host monthly art shows in the evening, teaming with a local bar to sell cocktails.

How can your local arts council facilitate a creative economy in your town? Consider working with them to start a creative economy business series, inviting small business owners into the discussion as well as teaching a community question-and-answer series.

Use the local library as a resource for bringing together the community. Is there space in your local branch to host movie nights or put on local plays? Is there space to use a meeting room for fostering like-minded community?

Team up with a restaurant to host pop-up dinners with visiting chefs.

Start a community garden.

Would your town benefit from a bike lane or bike paths? Work with the city to create one.

BEING A NEW PARENT IN A SMALL TOWN

When Sean and My had their first child, they weren't sure how their new family structure would work in Westerly. The couple didn't know what type of community they would find themselves surrounded and supported by. Their children are still very young, but they now have an image of the type of community they would like to see for themselves and other parents like them.

Having the beach so close is an easy resource, but looking past that, they would like more alternative education options in Westerly as well as more family-friendly restaurants. While there are some, making sure the town is attracting young families is important for growing or at least maintaining the population that it has today.

You can apply young-family-wants to any town, as many parents would like the same things for their children: a safe place to be outside, activities that will enrich their lives, access to nature, and a place where families can socialize together. Walkability is also a great indicator of how the town values community. Are there sidewalks? Sidewalks allow residents to get outside, walk safely, talk with neighbors, and be present in their communities. "There's a very small percentage of people making decisions on what happens in a town, right? And if the community doesn't become involved, then of course things aren't going to change. But once people advocate for certain things, then stuff changes. Our input has a lot more strength in a smaller community," added Sean.

ACKNOWLEDGE THAT YOU HAVE the power to create something if you want to in your town. You can create a better life for yourself or uplift the quality of life for yourself and everybody around you, whether by opening a small business for your community or just associating and socializing with a similarly civic-minded group of people. If you want to do it, you can do it. You can attend city council meetings, school board meetings, and the like. This type of involvement only helps a community reach its fullest potential.

TURNING YOUR HOME INTO AN INCOME-GENERATING PROPERTY

Sean and My found their home while stopping by an estate sale on the property. Sean noticed that there was a live-in garage attached, even though the main house was a bit smaller in area. The light bulb went off almost immediately, and he saw the potential to live on the property in the smaller apartment and renovate the main house as a short-term rental listing. This setup has provided the couple with the income and freedom to take on other projects.

On their land, they have chickens, a garden, and an outdoor space for their children to run and play freely. The land has provided them an opportunity to show other people the value of visiting, and potentially moving to, their small town. By sharing their vision for the town with others, they allow them the opportunity to explore their own vision as well.

That's the part of the hospitality world that Sean loves: "It's been really rewarding in that sense, turning new people on to this area who are like-minded and also sharing space with those people. In turn, they help us to appreciate what we have, you know, so it's been a win-win in that sense," said Sean.

WESTERLY, RHODE ISLAND

POPULATION: a little over 17,800

CLOSEST INTERNATIONAL AIRPORT: 38 miles to Providence

CLOSEST LARGE CITY: 43 miles to Providence; 79 miles to Boston, Massachusetts; 122 miles to New York City

Taylor Swift wrote the song "the last great american dynasty" about her beach home in Westerly.

Wilcox Park, designed by Warren H. Manning, is listed on the National Register of Historic Places.

You can find Sean and My at @seanwspellman / @southcountyhouse / @westerlysound / @ohmybubba on Instagram.

JOHN PETERSEN, WILLIAM KINNANE, AND RILEY KINNANE-PETERSEN

Banker and Creators of Fashion Brand Gunner & Lux

WARREN, MAINE

"Growing up in Nebraska, getting in my truck, turning on a great CD, and just driving, I guess, was like the best mental health thing I could do. You know, especially in high school and college, so much is going on. I would get in my car and just drive on the back roads. When we first moved here, just driving around all these roads and not having it be like it is in Atlanta where it's city, house, city, house, city, house, you know, it's all spread out. This [Maine] is incredible. I can just feel sort of like a weight lifted. You're just able to breathe in a small town."

JOHN PETERSEN

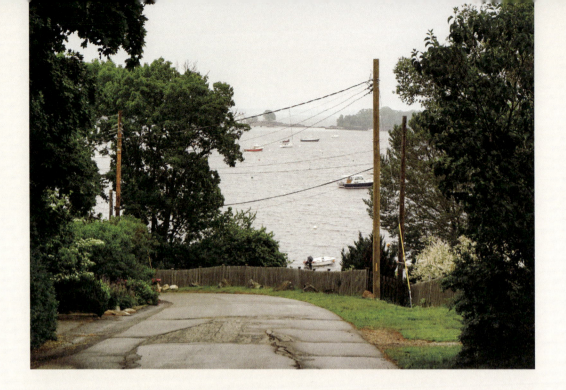

When John Petersen and William Kinnane adopted their daughter Riley, they never imagined that life would take them back to William's childhood hometown of Warren, Maine—and more than that, to the exact house that William's parents built together before he was born.

Moving from Atlanta, Georgia, was a big leap for the family of three, but one that has only brought them closer and allowed for more ideas, inspiration, and possibilities.

When Riley was five, she and John started a company together called Gunner & Lux. The brand has grown to include more than 400 wholesale accounts and has garnered press from around the world. Since the business could be run from anywhere and William was already working remotely long before the 2020 pandemic, making the move to Maine was seamless for the family.

FINDING THE PERFECT BLEND OF TWO DIFFERENT IDEAS ABOUT EDUCATION

John's parents were both teachers in Nebraska, so his upbringing emphasized the pros of public school, while William was raised in an environment that was anti-testing and anti-homework. It wasn't until the pandemic that the couple realized that even as home-schooling was not proving to be the right choice for their family, their daughter still needed an alternative to public education as we know it today.

Longing for more freedom than what public school could provide in Atlanta, William brought up the idea of moving the family to Maine and having Riley attend the school

that left such a positive, lasting impression on him—the Riley School, for which their daughter is named. The Riley School is committed to teaching a true love of learning, which was something that John and William really wanted to instill in their daughter. Riley is

thriving at school, reinforcing that the move has been an incredible experience for the entire Petersen-Kinnane family.

SMALL TOWN BONUS COMMUNITIES

The beauty of living in a small town is that you get a bonus community—maybe one that is five miles away or maybe twenty miles. No matter the distance though, you will get an extra town or two that will expand the services you have access to (see page 64 for a list of paired towns). For John, William, and Riley, their community stretches to include Rockland and Camden. Popping into antiques shops or museums in Rockland or shopping for a few gifts in Camden is extremely doable, as both are at maximum an eighteen-minute drive from Warren.

This drive might sound long, but think about it: if you live in a city, you might drive forty-five minutes just to get to a nearby restaurant—even if it's only a few miles away—because traffic can cause terrible delays. In a small town, you could be in an entirely different community in twenty minutes—one that gives you a completely different experience than what you might find in your own small town. These bonus communities make the small town experience even more exciting, as you get further away from the idea that you will have to sacrifice and do without by making the move to a small town.

WHEN THE SEMI-SOCIAL FAMILY GETS MORE SOCIAL

While they were not overly social while living in Atlanta, John and Riley have since found the community they both were searching for in Warren. In Atlanta, going out was often business-related, from fashion events to restaurant openings. Knowing that social events in Warren would not involve work was a big incentive for both Riley and John to get on board with a move.

Riley found a group of friends through school that align with her needs and beliefs, while John found a solid group of dads that make being social and getting together a priority. "I would say my social calendar has increased here, but like in a nice, fun sort of chill way," said John. William, who is more of an introvert, has also found the exact social outlet that he needed after a very busy workday by joining the board of the Riley School. He can be involved and get to know the community again after being gone for twenty years.

It seems so very picturesque. John and his group of dad friends take all the kids skiing in the winter, have nights around the firepit at the Petersen-Kinnane house, host regular group dinners, and have even started an ultimate frisbee league for parents and students at the Riley School.

WAYS YOU CAN OFFER TIME AND FUNDRAISING IDEAS FOR THE LOCAL SCHOOLS, EVEN WHEN YOU DON'T HAVE A CHILD THERE

Join the Parent Teacher Organization (PTO); more often than not, it's the same six parents doing most of the volunteering at any given school. Think of ways you could offer your time.

Help during a book fair.

Offer to read to a class.

Have a special skill? Reach out to a teacher and see if you could come and speak on the topic.

Volunteer your time during field day.

Have a business? Offer to have your business sponsor a meal for the teachers.

Buy the teachers a coffee.

Help the PTO fundraise.

Host a bingo night fundraiser.

Organize a 1980s-themed school dance.

Organize a kids' art show with a local gallery, with funds going back into the school.

Organize a costume closet for kids around Halloween, with money going to the school. Have parents donate their children's old costumes, which will provide options for children who wouldn't otherwise have access to costumes while also doing something great for the planet.

WARREN, MAINE

POPULATION: a little over 4,700

CLOSEST INTERNATIONAL AIRPORT: 52 miles to Bangor; 63 miles to Portland

CLOSEST LARGE CITY: 70 miles to Portland; 175 miles to Boston, Massachusetts; 294 miles to Montreal, Quebec, Canada

Don't miss out on the tag sales in the area, aka yard or garage sales. You can find lots of great vintage pieces at these sales.

Just 10 miles away, you'll find Rockland, a larger small town with museums, festivals, and rides, that sits right on the water's edge. Camden is just 18 miles away, and it has a lively downtown with lots of shopping, restaurants, ice cream shops, parks, and more.

You can find Gunner & Lux at @gunnerandlux on Instagram.

EAST

MIDWEST

SOUTH

WEST

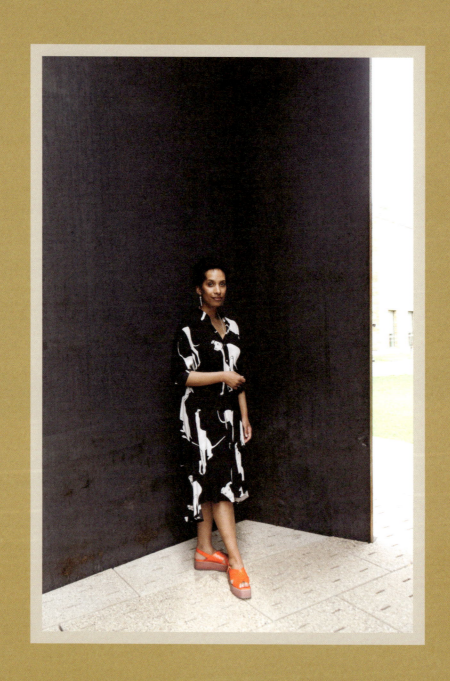

DAISY DESROSIERS

Chief Curator and Director of The Gund at Kenyon College

MOUNT VERNON AND GAMBIER, OHIO

"The potential that I see in this space is that we can reimagine how a teaching museum can advance creativity, foster curiosity, but most importantly, illuminate shared humanity between people, places, and ideas as a way to allow a younger generation—but also the community surrounding them—to really respond to the issues of our time. I'm not the author of this quote or this idea. But one of the reasons why I believe so much in museums and their civic responsibility is because I really do believe that we rely on the visual when language is not enough, when words are not enough. And in a moment where we've all witnessed intense change—the global pandemic, greater awareness of very different realities, and tension—I really do believe this is the muscle we need to work—being more acute thinkers, doers, contributors to these conversations and keeping the habit of engaging in meaningful dialogue, even when nuance can create some discomfort."

DAISY DESROSIERS

Daisy Desrosiers grew up in a rural community, surrounded by agricultural villages in the province of Quebec, before moving to Montreal. Later she moved across the ocean to Brussels, before spending some time in Chicago and Waterville, Maine.

It was the rural living of her childhood that prepared Daisy for her current role as chief curator and director of The Gund at Kenyon College in Gambier, Ohio. Passing cornfields and wide-open fields on the way to work each day is not especially different in many ways from what she saw as a child, with the exception of the Amish buggies that pass by from time to time.

Kenyon College is more than 200 years old, but the gallery opened in 2011. The college is well-known for its English department and literary journal, the *Kenyon Review*, and Daisy is excited to be at the forefront of extending the college's reputation in the arts. She can remember interviewing for the position and thinking that visual art requires a visual experience, so she needed to visit the campus before moving to the town.

The campus completely sealed the deal for Daisy. "For me, I kind of have a soft spot for any kind of project or initiative that starts with no idea of how it's gonna end. And driving to campus felt a little bit like this. I wasn't sure I was on the right road until I made it to campus. I love to imagine how a museum, how a creative experience, can be undetermined until you're there—you don't know what's waiting for you. And Kenyon certainly has this sense of wonder about it," said Daisy. Being

the director of one of the youngest entities on campus has left Daisy with so much room for experimentation.

WHAT PUBLIC ART MEANS FOR A COMMUNITY

You will find public art throughout the Kenyon College campus, which creates a museum without walls that is not only for the students, but for the community as a whole. "[We are] encouraging different manifestations of public art because public space invites conversations and opinions. The way artists can engage community partners, community members in thinking through the lens of what their practice is attempting to convey can be quite powerful," shared Daisy.

BRIDGING THE UNIVERSITY AND THE LOCAL COMMUNITY

"It's been such an exciting time to get settled here and actually build this community, and be a part of the existing community. It's just been so welcoming . . . it's coming together beautifully," said Daisy about the Mount Vernon downtown space—the Annex—that Kenyon College has created to bring the two communities of college and town together. Daisy believes that building a space is a big part of what museums can and should be doing. She encourages the community to learn about modern and contemporary art to foster life-long learners.

When she took the position at Kenyon, she found an apartment in Mount Vernon's downtown, just about nine miles from the campus. Even as a newcomer, Daisy could feel the warmth from her new community and was drawn to the way the buildings had been preserved.

Her creative wheels were spinning as she kept imagining how wonderful the architecture of a storefront is, and how complementary it is to a museum, which encourages visitors to think about this aesthetic experience. But with a storefront, there's an informal aspect to it because you can always see inside.

Through a partnership with the local public library, SPI—a STEM learning center for K–12—and a community center for retirees,

the downtown space allows for art collaborations, bringing the university to the center of town and connecting local organizations to the college through art-based learning programs. They named it the Annex so that other organizations could also feel ownership of the space to further connect the community. One example is Knox Alliance for Racial Equality (KARE), an organization offering a civil rights walking tour through the town, focusing on abolitionism, women's equality, and racial equality. Providing a place to meet was perhaps not part of the initial vision for the art space, but such unexpected connections are exactly the reason Kenyon College wanted to open it.

Daisy has found so much inspiration from mentors like Donna McNeil, director of the Ellis-Beauregard Foundation in Rockland, Maine, which supports the arts through a variety of programs and fellowships. "It's been so inspiring to me being in my early thirties, to meet someone at that stage in her life, who

only leads with creativity and follows artists and supports artists on that level. She's been such a model for what can happen in smaller places," shared Daisy.

THE ROLE OF A MUSEUM TODAY

As we question the history of places and practices, we have to ask how a museum can be part of telling that story and how it can be a part of the conversation for its community. The museum is left to consider who they are working for and who they are here to represent.

As a young museum on an academic campus, The Gund has so much potential for experimentation. Daisy sees the museum at the heart of what a college campus can offer, modeling life for a community of young adults as they figure out who they are and who they will be. It creates a space to take risks, and even invites failure, as a way of celebrating what can be learned from the process of experimentation and growth.

"The assumption is often that when you're in a rural place, you're in the middle of nowhere, and I actually think a museum collects stories and voices from different vantage points that makes us actually the middle of everywhere," said Daisy.

DAISY IS OFTEN ASKED WHAT IT'S like to live in rural Ohio, or rural Maine where she was before, as a minority. "It's mostly things that are very practical that can affect you deeply. Like, nobody can cut my hair. I'm just going to basic care where that's an impediment to feeling like you belong, based on your level of access to certain services," shared Daisy. These are the types of things that are often overlooked in some communities, but are vital for an inclusive experience.

FINDING A SENSE OF WONDER IN A SMALL TOWN

When traveling in a city, it's so easy to be hyper-aware of time, costs, and space. "There's a relationship with time that's very, very different in a city," said Daisy. While you might experience space differently in a city, walking from place to place, hearing the city sounds, and sharing space with others around you, in a small town you can engage with these things in another way entirely. The sheer landscape offers peacefulness, and the ease to move because you're not stuck in traffic. There's just something so fluid about being in a small town. You are set up to discover great things if you allow yourself to look for the sense of wonder that can only happen in a small town. It's not digital. It's not able to exist in the same form anywhere else.

SMALL TOWN MUSEUMS WORTH A VISIT

Abbe Museum Bar Harbor and Mount Desert Island, Maine

Alice Moseley Folk Art Museum Bay St. Louis, Mississippi

Ansel Adams Gallery Yosemite Village, California

Art Omi Ghent, New York

Bainbridge Island Museum of Art Bainbridge Island, Washington

Baseball Hall of Fame Cooperstown, New York

Buffalo Bill Center of the West Cody, Wyoming

Chinati Foundation Marfa, Texas

Clarinda Carnegie Art Museum Clarinda, Iowa

Crow's Shadow Institute of the Arts Pendleton, Oregon

Dia: Beacon Beacon, New York

Farnsworth Art Museum Rockland, Maine

Florence Griswold Museum Old Lyme, Connecticut

Gordon Parks Museum Fort Scott, Kansas

Grammy Museum Cleveland, Mississippi

The Gund at Kenyon College Gambier, Ohio

The Huntington San Marino, California

James Rose Center Ridgewood, New Jersey

Maryhill Museum of Art Goldendale, Washington

Mass MoCA North Adams, Massachusetts

National Museum of Wildlife Art Jackson, Wyoming

The National Voting Rights Museum and Institute Selma, Alabama

Norman Rockwell Museum Stockbridge, Massachusetts

Opus 40 Saugerties, New York

Parrish Art Museum Water Mill, New York

Pollock-Krasner House and Study Center East Hampton, New York

San Juan Islands Museum of Art Friday Harbor, Washington

Shelburne Museum Shelburne, Vermont

South Dakota Art Museum Brookings, South Dakota

Storm King Art Center New Windsor, New York

Taos Art Museum at Fechin House Taos, New Mexico

Walter Anderson Museum of Art Ocean Springs, Mississippi

Whitney Plantation Wallace, Louisiana

Winterthur Museum Winterthur, Delaware

MOUNT VERNON AND GAMBIER, OHIO

POPULATION OF MOUNT VERNON: a little over 16,800

POPULATION OF GAMBIER: a little over 2,000

CLOSEST INTERNATIONAL AIRPORT: 41 miles to Columbus

CLOSEST LARGE CITY: 40 miles to Columbus; 105 miles to Cleveland; 153 miles to Pittsburgh, Pennsylvania; 194 miles to Detroit, Michigan

Mount Vernon's downtown is listed on the National Register of Historic Places, with many buildings dating back to the mid-1800s.

The Ariel-Foundation Park is a local park that boasts 250 acres of trails, art, a museum, lakes, and more.

Tintype photography was conceived at Kenyon College by physics professor Hamilton L. Smith.

The Kenyon College dining hall for students was the inspiration for the dining hall in all the Harry Potter movies.

Notable college alumni include Paul Newman, John Green, and Adrian Galvin of Yoke Lore.

Visit The Gund at Kenyon College at thegund.org.

AVERY WILLIAMSON

Artist

YPSILANTI, MICHIGAN

"There's so much to learn. And I try to challenge any assumption I make about what this place is or has been, because I think you really have to spend time in a place to try to understand. And talk to more people. So I'm kind of humbled by moving to a new place [Ypsilanti] and feeling like I might never know it the same way I know the neighborhood I grew up in, but there's some joy in trying to learn and understand what's going on here."

AVERY WILLIAMSON

Living in a small town was a completely new experience for artist Avery Williamson, but one that she and her husband Kidus welcomed easily, particularly after growing up in Philadelphia, a city built on a series of connecting neighborhoods.

After college at Harvard in Cambridge, Massachusetts, Avery and Kidus returned to Philadelphia for a bit before moving to Ann Arbor, Michigan, for a doctoral program Kidus was attending. It was during that move that Avery found a studio space in the nearby small town of Ypsilanti, about twenty minutes from Ann Arbor. Two years later, she and Kidus began looking for a house to buy, and it was in "Ypsi"—as the locals call it—that she wanted to look. "I just felt safe there," explained Avery, about wanting to put down roots and begin

working from the community that she had gotten to know so well.

Ypsi sits between the two larger cities of Detroit and Ann Arbor. Previously, Avery might have thought of Ypsi as a transition space for her and Kidus, but the more time she spent living there, working there, and getting to know the community, the more it began to feel like its own unique place that offered something the outside communities didn't. Early on in the pandemic of 2020, Avery and Kidus almost moved to another big city on the other side of the country for work. But the idea of leaving the community Avery had become so accustomed to and grown to love so much was distressing, and made it clear to her that she's much more connected to Ypsi than she would have ever imagined.

WHEN YOUR SMALL TOWN DRIVES YOUR CREATIVE WORK

The nature that surrounds Ypsi and the history of the town have found their way into Avery's fine art career. She's just begun a yearslong project to study the trees, plants, and flowers that grow naturally in the area, as well as the waterways. It is all part of a larger body of work that Avery is excited to immerse herself in—part social justice, part science, and part history, it tackles the lack of clean water in the state, along with the origin story of the town, and the history of the plants that had been indigenous to the area (and how they can be reintroduced). Avery takes those hyperlocalized plants and uses their dye properties to drive the colors found in her work throughout the project. Through this multifaceted exploration she looks at how postwar industry has changed the natural landscape of Ypsi in particular, but also Michigan as a whole.

SMALL TOWN ARTIST

For many years, artists have been told that to be successful they have to live in a big city. This might have been the case many years ago, but just isn't so anymore. Artists are thriving in smaller and smaller communities all the time. And more than that, they are realizing that the high costs of living in a city are pricing out the creatives who helped mold and shape the cities in the first place. Artists have also been told they have to starve and give their lives to art to

HOW TO BE A WORKING ARTIST IN A SMALL TOWN

Show up for events to support the community where you want to see your work.

Allow your digital community to supplement your physical community.

Give yourself time to breathe.

Don't be afraid to share your working space with your digital community; you'll need to rely on those outside your town to find your work as well, when you're living in a smaller place.

Find the grants that cater to the small town working artists and apply for everything; winning one will afford you the most important thing an artist could ask for—time to create freely.

Treat the arts in your town as a community rather than a competition. You are all in this together and will need one another at some point. Be known as a helper instead of a hindrance.

Embrace the freedom to say yes to some projects and no to those that don't feel right. Find the joy in taking on projects that are just for you.

Create a mailing list for your clients and community so that you have a way to reach your broader audience, even if you are not engaged with social media.

Have a website for your work, even as an online portfolio, with a clear way to reach you.

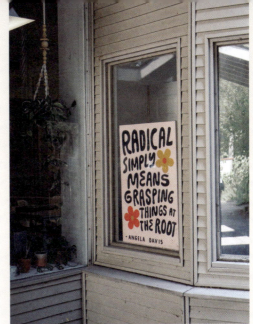

become successful. However, with the internet, they can have a very different life than artists in the past did. Creative people of all types can live in a small town, often with a lower cost of living, and still have a very successful creative business.

For Avery, while Ypsi's art community is small, she's found it to be incredibly supportive and encouraging of her work. And she's also come to understand that there is more than one narrative about what it means to be an artist or a person making art. Artists in Ypsi often still work full-time jobs in addition to having a robust art practice. "People are just doing what they want. It's not a big fundraising effort, or anything, just people doing cool, weird things," said Avery.

Avery makes times for walks and getting out into the nature that's all around her, taking in the area's diverse textures and looking for the quirky and unexpected design in her surroundings.

Cities can feel incredibly distracting for some artists. In Ypsi, Avery has been able to find a focus that allows her to go at her own pace within her creative practice.

Avery's backyard studio has also given her the chance to cut her overhead costs, and with that comes the freedom to delve more deeply into new bodies of work. This has also resulted in the space for the early stages of her own dye garden just steps from her creative doors.

ALLOWING YOURSELF TO TAKE CHANCES

Finding a small town that's also affordable is achievable, even though the cost of living has jumped in so many places. This was something that drew Avery to Ypsi as well. It's still affordable for someone to have an idea and try out a new business in Ypsi, without feeling

like there's going to be a catastrophic end if it doesn't work out. "I just really liked the energy of Ypsi, of a place where there's chances for people to shape it and shift it. And I just felt like that aligned with the kind of place I wanted to be, where there's more possibility," shared Avery.

It's these types of freedoms that have allowed Avery to work with other artists to create a makeshift gallery within a warehouse space in town. They have given themselves room and time to see what works, what doesn't, and how they can add to the cultural landscape of their town.

Without trying to saturate the environment with her big-city ideas for Ypsi, Avery is still in the fresh-eyed stage of living there, during which she is actively challenging assumptions about the place. She is in the observing–asking questions–looking phase. It's in that listening that she will gain a strong grasp of what the town really wants and needs, and where she will therefore want to put her time and energy.

YPSILANTI, MICHIGAN

POPULATION: a little over 20,000

CLOSEST INTERNATIONAL AIRPORT: 17 miles to Detroit

CLOSEST LARGE CITY: 9 miles to Ann Arbor; 35 miles to Detroit

Ypsilanti, commonly shortened to Ypsi, is the home to the first Domino's Pizza and Eastern Michigan University.

You can find Avery at @aisforavery on Instagram.

LEAH SPICER

**Owner of the Restaurants Homecoming and Reunion
and the Handmade Line Tom Kitten Goods**

SPRING GREEN, WISCONSIN

*"When I was a kid, I thought, it's such a small town. I know everybody.
But I think there's something really nice about knowing everybody in
a small town. There's a sense of accountability. You know, I feel like it
sort of makes you a better person, because there isn't that anonymity.
Everybody knows what your car looks like, what you look like. It sort
of causes you to rise to a better version of yourself all the time. And
I'm kind of grateful for that."*

LEAH SPICER

If you ask Leah Spicer where she, her husband, and their three children live, she will point out a few different locations, because her life primarily takes place in rural Wisconsin, away from a proper town. "We're smack-dab in the middle between Spring Green and Dodgeville. And Muscoda is pretty close. The closest town is seven miles from us, and it's called Avoca. To grocery shop, we go to Spring Green, and that's where our restaurant Homecoming is and our local public schools are there too," shared Leah.

With enrollment in rural public schools declining, Leah drives to another small town called Plain to drop her youngest child off each day at the Early Learning Center. "There's so much consolidation in the schools. I'm the clerk on the town board in Clyde township,

and when my older siblings were growing up, [what is now] my office was a high school, part of the River Valley District. They closed all these schools; there used to be schools in Lone Rock, Avoca, Arena, and Plain, and now there's only one in Spring Green," said Leah.

A START TO THE CITY VS. SMALL TOWN CONVERSATION

"Living in a big city was nice, but I really wanted my kids to grow up in a community where they know everybody and where everybody knows them. I like the idea that if your kids are in trouble everybody knows who they are, everybody knows who their parents are. Everybody knows who their grandparents are. So it's delightful in a lot of ways. It's really wonderful. We are so lucky in our town [Spring Green],

we still have a hardware store, we still have a grocery store. You pretty much have everything you need. But we also have a good coffee shop, we have a great bookstore, and we have a really beautiful home goods store. So that's really nice, and it isn't true of all small towns. And there's also more stuff happening—people are opening businesses in Spring Green; young families are moving here. So that feels really good, maybe even more exciting than when I was a kid," said Leah. But with rural living, there are some downsides, too. "You think, 'Oh, I'll move to the country. We'll have a garden and animals, which will also be lowering our ecological impact.' But then you're driving all the time and you think, 'Maybe this doesn't actually lower it,'" expressed Leah. While you do spend a lot of time in your car when you live in a rural area and the differences you cover might be greater, what takes you twenty minutes might take someone an hour in a bigger city due to traffic or congestion.

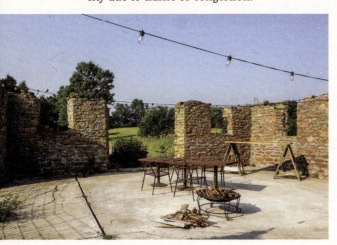

RURAL SOCIAL LIFE

Bigger cities tend to have a larger, more diverse social scene, and you have to make choices about how you spend your time and where to put your energy. It's important to be mindful to carve time out for yourself and to meet your own needs. "There can end up being some feelings of being left out of other groups, or just feeling that there are too many people to hang out with. There are too many social obligations [in a city]. And so I really like it, in this smaller setting, not feeling that pressure," shared Leah.

LEAVING BEHIND A GREAT LIFE . . . FOR A BETTER ONE

Leah and her husband Kyle had an ideal life in Asheville, North Carolina. The couple had the home of their dreams—a 1920s Craftsman with all the original woodwork—great friends, and a good job. So why leave it all behind to move back home? "I really love that this is the small town that I grew up in. It's multigenerational. There are people who knew me when I was a kid. And now they're seeing me raise my kids here. And that feels really special to me. It just feels like a real community. It's what I always wanted. Everybody knows each other. Everybody's looking out for each other. It's nice," shared Leah. But going deeper than that,

Leah wanted to give back to her parents, who have always been there for her and supported her in every way. "My parents have forty acres. They grow their own food; they do their own meat; they milk a cow. And as they age, all of these things that they do are going to become more challenging for them. So Kyle and I wanted to be able to sort of position ourselves to be the ones to take care of them and to help with the farm or to transition. The reality is that, really, my parents are the ones helping me. So I'm hoping that that balance can shift at some point here," said Leah.

RURAL LIVING REALITIES

There's what you imagine rural farm life to be, and then there's the reality of a homesteader's situation. You can't just plop down on a piece of land and have this ideal life from day one.

"The amount of work that my parents have poured into their land [is enormous;] . . . it's like a dream situation for Kyle and me. Everybody is moving to the country, to homestead or live out their dreams of having a simpler life. My parents' farm is 95 percent of the way there. The reality of actually going to a piece of land that hasn't been organically farmed for the last thirty years, and doesn't have all this infrastructure in place, is so hard. It takes forever. It's so time-consuming and so much physical labor," reiterated Leah.

WORKING FOR CHANGE WITHIN YOUR COMMUNITY

Homecoming, the restaurant Kyle and Leah opened in the summer of 2021, is a great example of a business that has had a really positive impact on the Spring Green community. Through the restaurant, they are able to provide employees with living wage jobs. "We source almost all our produce, meats, and grain locally. So that feels really good, to be able to serve and give back. And then we also do all our banking locally; we do all of our insurance locally; and we try to put as much money from the restaurant back into our community as possible. That feels like a really important way to serve our community and be engaged," shared Leah.

ANOTHER ASPECT OF RURAL LIVING to consider before making a move is that you may not have access to powerful, reliable internet connections, which will limit you in some ways. And while a little less connectivity might be something you are looking for, it's important to be prepared for the realities of what that will mean. It's also important to know that while the idea of lower property taxes may seem enticing, the smaller amount of funding impacts public services, such as the schools, often leaving them underfunded. Consider whether you will have to supplement your child's education before making the move. Also consider whether you will face a lack of medical facilities, public transportation options, or human services if you decide to undertake homesteading.

Aside from the restaurant, Leah serves as the clerk of her town board. This position allows her to go into the town's association unit meetings, which is a way to engage with the community, learn what people are struggling with, understand the kinds of opportunities that are available in terms of grant money, and the like. Leah also ran for office in 2022, hoping to flip the 51st Assembly seat for the state of Wisconsin. While she didn't win, she learned a lot about where she wants to focus her attention and drive going forward. "I might run for office again at some point. But right now, I'm just trying to figure out how to show up in my community—this small community, but also on a broader scale—to [try to] fix some of these problems that people are experiencing.

One that comes up all the time is the lack of childcare in rural areas. I've been meeting with childcare providers and parents about what to do, and there's some exciting stuff going on. So that feels good to start moving forward on that," shared Leah.

STAYING TO KEEP CHECKS AND BALANCES

While it might initially feel daunting to stay in a small town that doesn't always align with your political voice, it's important to invest your time in these places as well. Through your presence, you can help keep things balanced and approach your neighbors in open dialogue, showing that there are two ways of looking at the same problem.

"When we talk about the things—the issues that matter the most to us, our values—we're all talking about the same stuff, which is safety, opportunity, family. We're all talking about the earth, the land, preserving it, and taking care of it. And so I think that people who live in rural areas who have real relationships and opportunities, or interact with people who are from a different political party, have an incredible opportunity to make connections with people and to connect on value-based issues. [Which] I think could lead us to a place where people are voting more in line with their values. And then we see things shifting towards what the majority of people really want," expressed Leah.

SPRING GREEN, WISCONSIN

POPULATION: a little over 1,600

CLOSEST INTERNATIONAL AIRPORT: 118 miles to Milwaukee

CLOSEST LARGE CITY: 45 miles to Madison

Spring Green is almost 2 square miles.

Frank Lloyd Wright was from the area, and his firm designed several homes, as well as commercial and civic buildings, in Spring Green.

You can find Leah and her ventures at @leahspicer / @tomkittengoods / @homecomingspringgreen / @reunionspringgreen on Instagram.

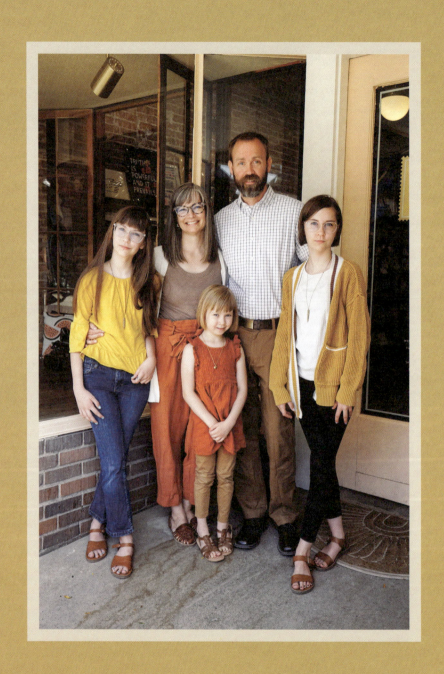

LAURA CAPP

Shop Owner of Postscript Press

ASHLAND, NEBRASKA

"What I've come to realize about Ashland is that there is something really charming to me about places that were never built with an eye toward impressing anybody. There's an unpretentiousness about the talent that has existed all these years. . . . They're here for the people who've chosen to be here. And it's like, that's all they need to do and be. I really appreciate it. There's an honesty there that nothing's surface-level about what happens in a small town. It's built with heart and hard work. And usually on a shoestring budget. Those kinds of concepts are inspirational to me. And, you know, that's something that I hope is true of my business, too, even though I like for it to have a little bit more shine. I hope people will find it to be unpretentious, and just welcoming and cozy and not a space where they have to pretend to be anything that they're not."

LAURA CAPP

Laura Capp grew up just ten minutes from where she now spends most of her days, at her paper goods shop Postscript Press, which opened in 2015 in Ashland, Nebraska. Though she never imagined that she would feel pulled to move back, she's now raising her three daughters with her husband Josh in the area that shaped her own upbringing.

After moving to Iowa City for graduate school in English, after which she planned to be a professor, Laura quickly became enamored with book arts at the University of Iowa's Center for the Book. While she was working on her dissertation, the couple decided to start a family—not expecting identical twins. "I couldn't see how it would work to have tiny twin babies and start a job as an assistant professor. So I reapplied to grad school through the Center for the Book's MFA program, and then when I finished that program, I decided I wanted a hybrid job where I could work with both literature and book arts," shared Laura.

Laura wasn't sure how to find this unicorn of a job, so she decided she would have to invent it. She envisioned a stationery and paper goods store with a workshop and studio space in the back and initially thought she'd have to set up shop in a city to generate enough traffic to make it work. "I thought I would open in Omaha [due to its size and foot traffic], but again, life intervened to make us pause. My husband ultimately wanted to live out in the country. I didn't want to be far away from where my girls would be at school. I didn't want to be commuting on top of workdays. And finding the kind of neighborhood

I craved (historic district, pedestrian-friendly) would have limited us to just a handful of very coveted and expensive neighborhoods in Omaha. Again, I'm super-practical and didn't want to take on a ton of debt for an experimental business when I had never run a business before," said Laura.

With the twins in tow, the couple decided to move back to the Omaha/Lincoln area and figure out their next move once they were in the region. A random off-the-highway moment would ultimately decide their next chapter. "I brought my twins for a preschool visit, and I randomly decided to drive down a highway that runs parallel to the interstate to grab cookies at a little bakery I had seen in Ashland, a small town about ten minutes from

where my parents live. When I pulled up, the neighboring building had a for sale sign in the window. I didn't think too much of it since my sights were primarily set on Omaha, but when we emerged with our cookies, I decided to peek in the windows. It was charming. We were able to go inside, as the space was being used for the town's newspaper office. It was a generous size for what I imagined and looked to be in pretty darn good shape. It had exposed brick walls and old wood floors, and as I drove away, every obstacle that had stood in the way of our decision-making fell away. It was three blocks from the elementary school. We could live in town for a bit and in the country later, and never have more than a ten-minute commute. While we hadn't planned to buy real

estate, it was so affordable it made a world of sense, both as an investment and as protection should my business succeed. So we took the plunge and have now lived here for eight years," exclaimed Laura. "I worried a lot about just not really having a clue as to what I was doing. I didn't think that I would really know how to run a business effectively for a while. And so there was something that appealed to me about being a little bit off the beaten path. I just felt like the level of expectation is maybe not as great or high in a small town as it would have been if I had been in a popular district. . . . [In the end] I felt like it would give me kind of the space and time to figure out what I was doing without as much pressure."

FINDING YOUR FAMILY'S NEEDS

When the school bell rings at three o'clock, Laura doesn't engage in the typical school pickup juggling that many of us go through. Since the elementary school is just a few blocks away from Postscript Press, and the Ashland library acts as a midpoint between the two, the girls are able to walk to the shop, often stopping by the library after school to read or check out a new book on the way.

"We were weighing our options, and I knew that Josh wanted to live outside of Omaha—but that would have meant at least a half-hour commute on top of a workday. Financially, it would have meant if I wanted the kind of location I was envisioning, [we would have had] a lot more overhead on a monthly basis to operate the shop. And there is just instability [if you don't purchase real estate], not knowing if your rent is going to be increased year to year, and not knowing if you're even going to have access to the space year to year," explained Laura. "[Buying the space in Ashland] just reduced the number of logistical complications that we can ensnare ourselves in [as small business owners]. And there's just no traffic to deal with living in Ashland. It's just kind of easy. It's an easy lifestyle that takes a lot of the stressors away that you just sometimes have when you're living in a bigger place."

GENERATING THE CREATIVE COMMUNITY YOU WANT TO LIVE WITH

In addition to the programs Laura offers to the community through Postscript Press, she's also a member of the local Chamber of Commerce, has spent some time on the Board of Humanities Nebraska—the statewide National Endowment for the Humanities program—and plans to one day join the board of her local library. She also works closely with the economic development executive director for the town's historic downtown, and Laura and her staff spearhead the planning for Hometown Christmas, the town's annual holiday program. Laura's love of book arts also informs her contributions to the town's creative community, as she creates leather-bound journals for the Young Authors Awards each year at the local school. And she applies her background in literature when hosting poetry readings in her shop.

Laura also plans to execute even bigger ideas over time. "One of the things I'm really excited to do is start a reading series at the new auditorium. Omaha's got a great independent bookstore called The Bookworm that's been there forever. And Lincoln has a couple [bookstores as well]. I want to collaborate with those bookstores. And you know, [our location] is halfway between Omaha and Lincoln— pretty exactly. It's a lot on a given evening to drive from Omaha to Lincoln or from Lincoln to Omaha. But to drive half an hour is more accessible for people during the week. I think it could be a really successful and fun series. It's been nice to bring educational kinds of things to town and to try to expand the number of opportunities that are available for arts and culture. I love that dimension of life," Laura gleefully shared. She's not been shy about working to bring diversity awareness to an

otherwise less-than-diverse community, from hosting Juneteenth events and fundraisers to participating in Black Lives Matter marches. "I'm trying to be a supportive space. Giving kids access to books with characters who reflect the range of human experience is really important to me," expressed Laura.

UNDERSTANDING HOW YOUR VISION FITS INTO THE TOWN'S VISION

When a community grows too fast, it risks losing some of the charm and appeal that drew people to it in the first place. "We've come to really love living in a small town, so I feel wary of too much growth too quickly. I feel like it can change the character of a place in a hurry if people aren't careful about it," expressed Laura.

Ashland is growing, and Laura voiced concern over how her own efforts might have contributed to that. "I think that a growing community is a sign of health to a degree. But I also think that there's this hard tension

that's at play sometimes. People and families have been living here for many generations. Ashland has always been a small place. And so I don't want this to feel like it's not their community anymore. I assumed that since a lot of people were here living in a small town, the broad desire would be to keep it small. But there are a lot of people who seem to think the growth is great. It's worth having conversations about the different directions that we can possibly take things, and I would say our downtown—our little strip of shops and restaurants and whatnot—has definitely become more of a tourist attraction over time. When we get to the weekends, you see a lot of traffic from Omaha and Lincoln. That's a reality; that's not a bad thing. I think it's one of the things we have to offer—a beautiful, charming, small town experience. But at the same time, I'm just trying to be really sensitive to what it's like to live here as a resident and watch your community change. And I don't

SMALL TOWN LIVING

want to make decisions that alienate that population, that native population that's been here for a long time. I have to think growth is good, but I think it's good to take a really long view of it, going at a slow pace and not necessarily courting [additional] growth if it's already happening. We have those kinds of conversations in our creative district meetings. . . . [When discussing priorities, we ask:] Are those projects going to benefit the existing residents? Or are they going to be more geared toward a tourist? That's one of the biggest struggles [of living in a small town]," shared Laura.

VARIETY IN FOOD ISN'T ALWAYS front of mind in a small town. The local grocery store might not have things like avocados, cilantro, or oat milk. Be prepared to take extra steps to get things you previously were able to find quickly. It's not the time to criticize your new home, but rather to embrace the charm and quirkiness of local retail. You have to plan out a little further to get things that are important to you. Can you make the time for biweekly trips to a larger grocery outside of town? Or you might seek out a small town that is closer to a big city and can offer you a greater variety of grocers and specialty food stores.

SMALL TOWN SHOPS THAT FEEL LIKE THEY BELONG IN A BIG CITY

Cicada Oxford, Mississippi

Cold Spring Apothecary Cold Spring, New York

Laurel Mercantile Laurel, Mississippi

Lawrence Street Provisions Port Townsend, Washington

Minna Hudson, New York

Salt Creek Mercantile Ashland, Nebraska

Three Potato Four Media, New Jersey

POPULATION: a little over 3,000

CLOSEST INTERNATIONAL AIRPORT: 144 miles to Des Moines, Iowa

CLOSEST LARGE CITY: 29 miles to Lincoln; 30 miles to Omaha

FESTIVALS NOT TO MISS: Stir-Up Days, Hometown Christmas

Ashland was awarded the first Creative District Development Grant in the state of Nebraska.

You can find Laura at @postscript.press on Instagram.

EAST

MIDWEST

SOUTH

WEST

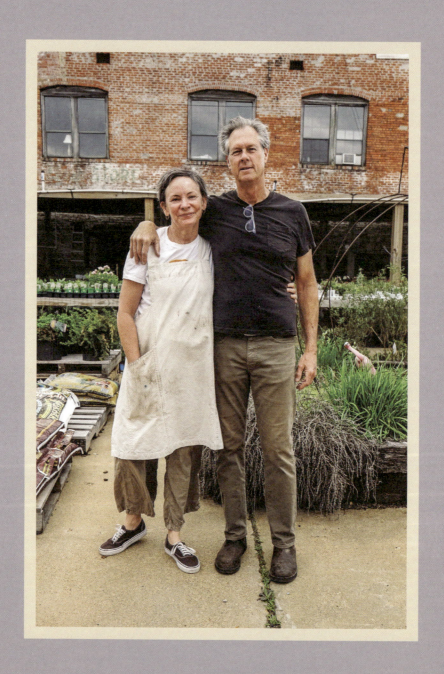

CHARLES "CHUCK" RUTLEDGE AND ANN WILLIAMS

Hoteliers of Travelers Hotel, Architect, Shop Owners of Collective Seed, Nanobrewery Owner of Red Panther Brewing Co.

CLARKSDALE, MISSISSIPPI

"I think that we could just keep this fragile momentum going in a way that fills more storefronts downtown. As people realize the affordability of this community, and everything it has to offer, they spill out into the neighborhoods around downtown [which has created] stronger and more stable, safer neighborhoods. And, you know, my dream is that one day this will start to improve. There's been some movement on that front for sure with the charter school. But you know, there are just so many little things that need to be inching along, together. You can't just go downtown and expect people to move here when the public schools are all failing. So there are just so many things that are tied together that have to act in concert. But again, I do think that tourism has the potential to continue to carry and grow Clarksdale, but [the economy] needs to diversify."

ANN WILLIAMS

Charles "Chuck" Rutledge and Ann Williams both crisscrossed the American South, though each of their paths looked different. Charles grew up in Clarksdale, Mississippi, before leaving for college in Nashville, Tennessee, spending time in Texas in Austin and Dallas, living for many years in New Orleans, and finally finding himself back in Clarksdale. Ann moved around the region, too, bouncing from Baton Rouge, Louisiana, to Birmingham, Alabama; Atlanta, Georgia; Washington, D.C.; and New Orleans, where a chance meeting brought her and Chuck together. Now they live together in Clarksdale, where they run a shop, a hotel, and a brewery, as they work continuously to grow the creative community in their Mississippi Delta town.

FINDING BALANCE WITHIN YOUR SMALL TOWN LIVING

The average person would be exhausted by all the ideas and projects Chuck and Ann have their hands in, but as a team, these two seem to tackle their goals with clear eyes and vigor. The couple bounces from their Travelers Hotel to their home goods and garden shop Collective Seed & Supply Co. They check in on their various home renovations, nonprofit organization, and brewery. They sit on several city boards, help spearhead a public arts program, and even oversee the planting of the superbloom along the Sunflower River.

About their seven-day-a-week workload—by choice—Ann remarked, "We find finding balance to be our biggest challenge. But other than [maybe] a pause button [that would let

WAYS TO FIND BALANCE WHILE LIVING IN A SMALL TOWN

Understand that you don't have to do all the things, all at once. Pace your ideas.

It's okay if you don't support all the events, every time. Know that you will need to show support to continue having events take place in your town, but don't let guilt drive that support or force you to overextend yourself.

Lean into changes and shifts in your goals and ideas.

Build a creative hive of like-minded people. Have weekly lunches together to bounce ideas off of one another. Ask them for help, and offer to help them.

Take time for yourself. Hit refresh. Your mental health is as vital as seeing your creative ideas come to fruition in the world.

Take a walk in the woods.

Get involved with organizations that spark your interests. Lean on them to help you with what you might want to create in your town.

us] just sit for a few hours a week, I don't know that I would change anything about it. We love what we do." While many people move to a small town to find balance, Chuck quickly pointed out, "We have less balance here than we did living in a city."

HELPING TO CREATE THE SMALL TOWN YOU WANT TO SEE IN THE WORLD

"We very much stand on the shoulders of people who came before us and started doing really cool things in Clarksdale long before we got here. But it was still early enough [when we arrived] for us to create what we want to see in the town as well. Clarksdale is a fascinating sort of petri dish. You can kind of do anything you want here, within reason. And people are just like, 'Oh, cool. Let's support that,'" shared Ann. "And there's a very small lag time between action and impact. Like, 'Oh, we just kind of talked about that the other day, and now it's happening.' And that's supercool." It's not lost

on Ann and Chuck that this sort of action and implementation doesn't happen everywhere.

Something to understand about the Mississippi Delta—the area of land along the Mississippi River that is also one of the most economically challenged areas in the country—is that it has a lot of food insecurity. To address that, Ann and Chuck have worked to grow the grocery section of their Collective Seed store. "We're just trying to bring in more healthy food options to the store. We do a farmers market in the summer, we work with local farmers, and we're starting to work in partnership with For a Healthier America, Michelle Obama's nonprofit, which does a lot of food injustice work. We're just trying to get locally

grown, healthier food to the community, and also make enough money that the store can survive in the process," said Ann.

They also need Collective Seed to survive and thrive for the artists who use it as a home base. Artists live on-site upstairs from the shop. Through this beautiful, community-run, shared environment, Ann and Chuck have created a place for artists to have the space to create. They offer studio space, space to live, and relief from the financial burdens of being a creative, in exchange for work hours at both the shop and their hotel.

Modeled after the now defunct artist-run hotel in Brooklyn called 3B, Travelers Hotel filled the space of a building that was otherwise sitting empty. Before Travelers Hotel opened, there wasn't a place for larger groups of people to stay downtown, in the heart of Clarksdale. Now, it's a gathering spot. "Last night we had this fundraiser. We had a local

SMALL TOWN CREATIVE AND CULTURAL RETREATS AND RESIDENCIES

Anderson Center Red Wing, Minnesota

The Blue House Water Valley, Mississippi

Blue Mountain Center Blue Mountain Lake, New York

Carbondale Clay Center Carbondale, Colorado

Corsicana Artist and Writer Residency Corsicana, Texas

Ellis-Beauregard Foundation Rockland, Maine

Elsewhere Studios Paonia, Colorado

Greenfield Farm Writers Residency Oxford, Mississippi

Hedgebrook Women's Writing Center Freeland, Washington

I-Park Foundation East Haddam, Connecticut

JX Farms Cleveland, Mississippi

Kimmel Harding Nelson Center for the Arts Nebraska City, Nebraska

MacDowell Peterborough, New Hampshire

Marble House Project Dorset, Vermont

Mesa Refuge Point Reyes Station, California

Millay Arts Austerlitz, New York

Monson Arts Monson, Maine

National Park Artist-in-Residence locations vary

Oasis Cabin Resort Maupin, Oregon

The Rowe Center Rowe, Massachusetts

Storyknife Writers Retreat Homer, Alaska

Travelers Hotel Clarksdale, Mississippi

Ucross Clearmont, Wyoming

Willapa Bay AiR Ocean Park, Washington

musician playing and he was selling the guitars that he also makes. Chuck was making cocktails [and we were] trading cocktails for donations to this nonprofit that we love. And . . . [as a result] you've got Clarksdale people hanging out in the lobby, interacting with guests from the Netherlands, because 40 to 50 percent or so of our guests are international," shared Ann. "Just so many cultural things happen at the hotel and I think that's really cool."

From an economic development perspective, an arts and culture perspective, and a community-building perspective, Ann and Chuck are continuously creating the small town they want to see in the world. They have more ideas than one person, or couple, could do in a lifetime, and they've found the perfect little town in which to bring them to life.

CREATING AN ARTS COMMUNITY IN YOUR TOWN

"I'm really excited about the public arts program [we're working on in Clarksdale], because it's so visual. We're trying to create a living, working public art program that recruits artists to make art here and bring art here. Not every artist has to live in Clarksdale to participate. We want to create a sculpture garden along a two and a half mile walking path, surrounded with art. We also want to sell art here, so that we can recommission a new piece. It will be constantly changing, [taking inspiration from the visual of] the Sunflower River, which is our little river that runs right through downtown. I think when people see that, I may be wrong, but I feel like they'll go, 'Wow, we can do something pretty remarkable here.' We'll bring more people here to live— artists in particular," expressed Chuck. "Also, the high school [building] is across the river from downtown, and it's been vacant for years. We want to make that a live-work studio and an art center that is the sanctuary in the neighborhood. You know, it's just a block from the river, but it's in the neighborhood that is away from downtown. We want to start reaching into neighborhoods that way, and have [art and resources] available for kids."

When we have ideas that seem grand, small towns offer us the opportunity to let them shine. That's because, in a small town, it is more likely than not that you'll find someone who sees your vision and can help you tackle your ideas. There are also often grants that target small towns, which can help bring your vision to life.

THE PERFECT WEEKEND IN CLARKSDALE

"You've got to go to Red's—non-negotiable. Breakfast, you have to go to Grandma's House of Pancakes and talk to Tina. We go to Hooker a lot for dinner. Levon's is also great. We have to send people to Abe's BBQ. We also like Kenoy's, just out on Friars Point Road, just past the community college. You can get a $3 burger and sit in the parking lot and drink Budweiser. It's in the middle of a cotton field and it's great. [If I were visiting, I would walk] around downtown, looking at art and walking along the river, [before] getting out to the big river [the Mississippi River], and going canoeing with John Ruskey of the gem of Clarksdale, Quapaw," shared Ann and Chuck collectively.

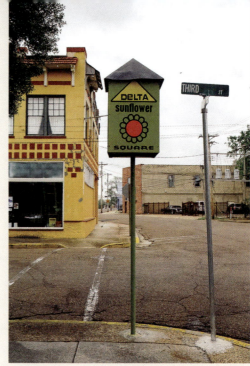

CLARKSDALE, MISSISSIPPI

POPULATION: a little over 14,400

CLOSEST INTERNATIONAL AIRPORT: 73 miles to Memphis, Tennessee

CLOSEST LARGE CITY: 76 miles to Memphis, Tennessee; 147 miles to Little Rock, Arkansas

FESTIVALS NOT TO MISS: Juke Joint Festival, an internationally attended festival in April, and the Sunflower Blues and Gospel Festival in August

The Mississippi River is 15 miles to the west.

Famous people from Clarksdale include Sam Cooke, John Lee Hooker, Ike Turner, and Muddy Waters. Actor Morgan Freeman is a business owner in town with his juke joint Ground Zero.

Clarksdale is known for its blues music and as the place where Robert Johnson sold his soul to the devil at the crossroads of Highway 61 and 49.

You can find Ann and Chuck and their endeavors at @welcometotravelers / @redpanther.beer / @collective.seed on Instagram.

SARAH COLE

**Chef at Abadir's and Founder of the
Nonprofit Black Belt Food Project**

GREENSBORO, ALABAMA

"At this stage of my life, I very much appreciate Greensboro, because I feel like I don't get so easily distracted by all the things that are taking place in the world. Being in a slower environment and being around nature and things that are green, it sort of allows me to focus on the things that I'm trying to accomplish and the person that I'm trying to be, whereas, when I was younger, I was very frustrated by being in this sort of environment."

SARAH COLE

After bouncing around her home state of Alabama, then spending a few years in Pittsburgh, Pennsylvania, chef of North African foods and pop-up restaurateur Sarah Cole felt the Black Belt (an area named for the region's rich, black soil) and Greensboro calling her back.

"It's just been a weird transition, the working-for-yourself sort of thing, in this space that I grew up in and around. I run [my restaurant] Abadir's. And then I started the nonprofit [Black Belt Food Project] and a lot of my time and energy is really dedicated to that. I think when I moved back, I had this dream of, 'Oh, I'm gonna have like this great work-life balance, where I'm gonna be able to work for myself. And then have all this time to do all the other things that I want to do. But really,

the majority of my time is spent building Abadir's. I would just say, I'm playing catch-up at this point, because I didn't think things would move so quickly with the business. And then I'm figuring out how to get things moving with the nonprofit. And then, of course, we have our big project house that we decided would be a good idea to buy. But really, it's not like the house is in great condition. And so a lot of our free time is spent painting rooms or dreaming up ideas for like the future space. I will say that when it's warm, the majority of my time, when I'm not at the kitchen or doing computer work and things like that for the business, I'm always outside. One of the greatest benefits is the house we have sits on an acre of land in town. I spend a lot of time building gardens. I have this really great vegetable garden that

SMALL TOWN LIVING

I dedicate a lot of time to. We have a few community events that happen. And for the most part, you're creating entertainment for yourself. So it's hanging out with friends or just riding back roads and trying to discover new things and just enjoying the scenery that surrounds you," explained Sarah.

THE AHA MOMENT

The 2020 pandemic taught a lot of us a lot of things. For Sarah, it was the motivation that she needed to act on ten years' worth of dreaming. It led her to the moment of realization—the "I'm going to do it now" moment. "I always say that Pittsburgh was my refresh stage," said Sarah.

She worked a variety of jobs as she tried to find her footing in this new-to-her city, establishing a base of experiences for herself in Pittsburgh. She was running a farmers market, working at the library, and working at a bakery as well. "I always knew that I wanted to do something food-focused at some point in my life, but I just didn't know what or how I wanted to go about doing it. And so, I think the farmers market put things into perspective for me," shared Sarah.

With a passion for food and the idea that she could give back to a community, rather than simply opening up a café or restaurant, she devised a new life plan for herself. When the world shut down, Sarah found herself working full-time at the bakery in Pittsburgh.

TIPS FOR STARTING A LONG-TERM BACKYARD GARDEN

Plan out your space before digging.

Think about what's native to your region and zone.

Think about how to grow as organically as possible.

Watch the sun before deciding where to plant. Think about how it moves over your land and how the seasons grow and change around you.

Go vertical if you are short on space.

Start a compost pile or bin.

Plant year-round for a four-season garden if your climate supports it.

She would sink into an almost meditative state, rolling out pastries in the back room day after day. Each day, she would talk for hours with a friend. "We would just talk a lot about things that we had always hoped we would do. And, you know, there was a lot of fear of like, 'What if things don't actually change or things don't get better, and we're just sort of trapped in this pandemic stage forever? And [what if] I never took a leap or did something that I really, really wanted to do?' There was just this moment of [thinking] I just have to try," said Sarah. "I had a friend who always said leap and the net will appear. I'm very much a planner. So to [leap] was terrifying."

Turning to her old notebooks for inspiration, Sarah kept seeing the same through line of imaginary menus, café logos, and designs. It was then that Sarah knew she just had to go for it. While her daydreams often brought thoughts of the desert, she also knew returning to a place like Greensboro, a place she already had a connection to, was what she was ultimately being pulled toward.

Sarah's business, Abadir's, showcases her Egyptian-meets-Southern roots. "It's been a good mix of very positive support and excitement [about opening Abadir's in Greensboro]. But then . . . it is a very rural community where things are essentially the same across the board—same types of foods, same types of events. It's just a very rural Alabama lifestyle. There's still a group of people who are very confused by what I'm doing. I've realized that I'm not going to please everyone. And I just have to keep working away at it. And, eventually, maybe someone who isn't so interested in it, or is confused by it, might give it a chance one day, and if not, then that's fine too," expressed Sarah. "I've built up a community of people who are really following along and wanting to be a part of Abadir's growth. People have been very supportive, kind, and encouraging, especially in very low and stressful moments. But, overall, it's been really a really good, energizing, but stressful experience."

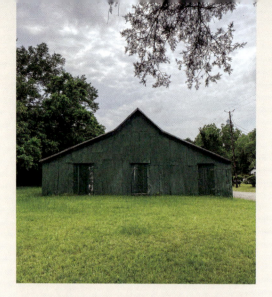

BECOMING A SMALL TOWN LOCAL without conforming or losing yourself can be difficult. It's hard not to dive in and do all the things on your list right away, bringing to life features that you feel your new town is missing. But rather than alienate anyone, take a step back and try to determine what your new town really needs. Who are the people you want on your side, supporting your new endeavors? How can you approach those people and have them appreciate what you want to do? If we jump in and immediately try to disrupt what those before us have been doing, they will often take offense and may not warm up to you and your ideas. Lean into the process of getting to know your town and how you can best be a part of its future.

FINDING YOUR PEOPLE

Creating a community for yourself in a small town often means looking beyond your immediate vicinity. "We spend a lot of time in other neighboring cities and towns. We go to Selma and we go to Tuscaloosa. I think . . . people who feel a little bit different [in these smaller communities] are immediately drawn to one another. So I think it was fairly easy to make friends here because people get excited [to meet someone who has similar ideas and dreams]. I mean, I get excited when I meet someone who's trying to do something a little different in this area. And you immediately latch on [to them] because you need that sort of support system. So making friends has been a little bit easier than I thought it would be. But at the same time, it's also difficult because we might not be living in the same town for the day-to-day," shared Sarah.

When your town is small, and you might see the same people every day, finding the community network that works for you is vital. Moving to a small, rural area can be so isolating; discovering your people gives you a taste of the community life that allows you to function. This isn't so dissimilar to a big city, where neighborhoods within the city can operate much like their own small towns. Friends move closer to one another; gatherings happen; you know the shopkeepers around you; you walk to your local grocery; you walk your dog past the same stoop each day; and so on.

Finding that sense of community within a small town is only different in scale. You just need to know where to look for your people.

CONNECTING COMMUNITY THROUGH FOOD

There are so many ways that an individual can connect to food. It is, of course, a necessity. But there are also stories and memories associated with food that can open up conversations between people who might not have communicated otherwise. "I do believe food can be the sort of connecting force. And that's what's fun about doing the Egyptian and North African take on things—it really has opened up some communication. Even going to the grocery store, people who I never thought would talk to me or be interested in what I'm doing want to know about the food and the ingredients. They want to know why this is like this, and they want to try things. And so yeah, I think we do connect through food. I'm hopeful on that. And it has essentially kind of worked already," shared Sarah.

Together with Abadir's and the Black Belt Food Project, Sarah is working to provide access and education around different, more wholesome global foods in areas experiencing food apartheid. The Black Belt Food Project is working with farmers and producers to provide greater access to those food producers. "You have to remind yourself that there hasn't [historically] been access to these certain foods. So, essentially, you are teaching people about different foods. It's not just Egyptian food. It's food in general. But with the Black Belt Food Project, we're building classes and programming and things centered around educational experiences," said Sarah.

GREENSBORO, ALABAMA

POPULATION: a little over 2,500

CLOSEST INTERNATIONAL AIRPORT: 95 miles to Birmingham

CLOSEST LARGE CITY: 95 miles to Birmingham; 100 miles to Montgomery

Visit Sarah's work at blackbeltfoodproject.org / eatabadirs.com; follow her at @eatabadirs on Instagram.

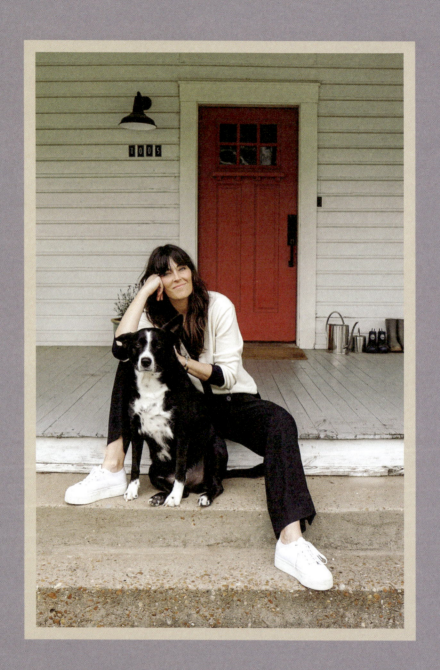

HANNAH A. CARPENTER

Illustrator at Little Biscuits and Content Creative

SEARCY, ARKANSAS

"I think one of the special things about staying where you grew up is just the history that you share with your kids. Like, 'Yeah, I know that teacher that you have.' The same goes for marrying someone who grew up where you grew up; you have so much shared history. And you can relate so much to each other on different levels."

HANNAH A. CARPENTER

Located around an hour from the Arkansas state capital of Little Rock sits the small college town of Searcy. The Carpenter family—Hannah, an illustrator, and Heath, a college professor—are raising their blended family of four children. Both Hannah and Heath grew up in Searcy, went to college in Searcy, and, after some time in Little Rock, found themselves putting down roots back in Searcy.

At first, the draw to stay was situational—job and family. But as time passed, they became more and more embedded in their small town in Northern Arkansas. "The longer you are in a place, the more connected you become. Your kids become connected there. And then it's like, well, you're here. But you know, living here, I have learned to appreciate things that

I've never appreciated before," shared Hannah, "like the community, the pharmacist, the doctors. And I appreciate being able to get from one place to another, one end of town to the next, in ten minutes. Especially as your kids get older, it's really nice for them to learn to drive in a place that's not terrifying."

CREATING A PLACE FOR YOUR TEENAGE/ COLLEGE SELF

Searcy is full of young adults with fewer options for how they spend their free time. For many years, Hannah has wanted to create a fun space for the younger population, giving them something she wished she'd had as a child growing up in Searcy. "I wouldn't be doing this in another place where it might already exist. Being in a small community gives

TIPS FOR RAISING TEENS IN A SMALL TOWN

Provide community based on their interests.

Meet emotional needs of the teen.

Allow the teen to be who they are.

Ask them how they want to be a part of the town and the community.

Help them connect with peers.

Allow them to feel valued in their small town.

Listen more, talk less.

Recognize boredom in your teen and provide resources for combating it.

You have so much freedom in small towns. Find the push and pull of that freedom, giving them space while still knowing what they are doing.

you an opportunity to grow and really help a place develop, or bring something to the table that's not there. I've kind of had to realize that the responsibility is on people. Like I sit around thinking, 'Why aren't there more cool things here?' Well, it's because cool people will have to do the cool things to have the cool offerings. So [living in a small town] makes you take a hard look at yourself and decide: are you going to participate in the community and do something [or not?]—which is what

I've been thinking about lately for myself," shared Hannah.

Her dream space would be akin to a rec center with really good pizza. It would be a place where artistic kids would have room to express themselves and where they could be introduced to interesting movies and films. Local bands could find a place to play, and the space could host cool retail and game nights. Essentially, her dream is to create a place where the kids on the fringe feel safe expressing their whole selves within a more conservative town. "Another thing about growing up here is that there are not a lot of places for kids to work. [At the dream space] they can learn about different jobs. [Right now,] that's lacking in a small town. You don't have teens seeing people doing interesting, creative work here. So maybe it would be an avenue to open their eyes to what's possible," shared Hannah.

THE WAGES OFTEN GUIDE LIFE IN A SMALL TOWN

Small town wages are calibrated to small town life. This can make leaving difficult, once you've established your baseline income and become comfortable with the lifestyle that that affords you in your town. Having the money to cover small town prices doesn't always translate to life in a big city.

For Hannah's oldest daughter, this financial reality influenced her decision to stay in Searcy and attend Harding University, where Heath works as a professor. It simply made the most sense for her to continue her studies close to home.

Small towns have the ability to suck you in and keep you financially comfortable—this phenomenon is sometimes called the *velvet ditch*, and it can make it hard to look past the county line.

NATIONAL ORGANIZATIONS THAT AWARD GRANT FUNDING FOR CREATIVE IDEAS IN SMALL TOWNS

Amber Grant for Women	T-Mobile
FedEx	U.S. Chamber of Commerce Dream Big Award
MBDA (Minority Business Development Agency)	USDA Rural Business Development
Our Care	Venmo

This isn't necessarily a bad thing, and many people are drawn to small towns because of the relatively high standard of living they can afford on lower wages than they would need in a bigger city. But it is important to remember that making changes once you are settled and comfortable can be difficult and may keep you in the small town environment longer than you had initially intended. With this in mind, think carefully about your long-term goals before making any big moves.

THE INTERNET BRINGS NEW LIGHT TO SMALL TOWNS

"When I was growing up here, I didn't want to live in Searcy. I always wanted to get out and live in a city—just anywhere else. I was starved for inspiration. . . . But those were the days when the internet was in its infancy. I would just pore over [fashion] magazines. We didn't have access to the world like you have access now. You don't feel so closed off from the rest of the world when you have the internet," expressed Hannah.

With the proliferation of internet access in small towns, as well as the current push for fiber-optic networks in rural communities, we are beginning to see a shift in jobs and information that people can access from their small town communities as well. People are now able to obtain some of the comforts of metropolitan life, and its corresponding work-life balance, from their small town of choice.

SEARCY, ARKANSAS

POPULATION: a little over 23,000

CLOSEST INTERNATIONAL AIRPORT: 41 miles to Little Rock

CLOSEST LARGE CITY: 51 miles to Little Rock; 95 miles to Memphis, Tennessee

Searcy is a small college town, home to Harding University.

Searcy is in a dry county, which means that there aren't bars or liquor stores. However, restaurants are allowed to sell alcoholic drinks. This is common throughout the South and isn't unique within the region.

You can find Hannah at @hannahacarpenter on Instagram.

BUNNIE HILLIARD

Bookstore Owner at Brave & Kind Books

DECATUR, GEORGIA

"My dream is to help create even more community within our community."

BUNNIE HILLIARD

With her background in marketing and financial services, Bunnie Hilliard felt like a square peg in a round hole because she was always more drawn to creative experiences than others in her field. After attending college in Florida and living for a time in Arizona, Bunnie returned to the South and settled in Georgia. After she and her husband started a family, they gravitated outside of Atlanta to the small town of Decatur, which is part of a rambling series of small towns, each with their own unique identities that flow from one town line to the next in the greater metro area. "We have our own identity. It doesn't feel metropolitan; it still feels like hometown-y. Decatur feels like a small neighborhood," shared Bunnie. "It doesn't feel like we're competing for attention as much as we are trying to serve our community and create community."

BUILDING WHAT YOU WANT TO SEE IN THE WORLD

When Bunnie decided to stay home with her two children, she found early on that many of the stories she read to her children didn't have characters that looked like her own family. Children's literature was lacking in diversity at that time.

"When I started my own family, I wanted to find books that shared faces and stories that look like my own children's faces and stories," explained Bunnie. When her daughter was about five years old, Bunnie started a book club for her daughter and her friends, hoping to give them positive associations with learning

to read. It was then that Bunnie's friends encouraged her to expand on the book club in some way. She did, and the Giggle Girls Book Club—a subscription-based book service for girls aged four to eight—was formed. "That was kind of my first foray into what has become Brave & Kind Books. It was me wanting the opportunity to get children excited about reading, and my curiosity and need to try and find as many diverse and representative books as I could for my own family and others," said Bunnie.

While Decatur is very close to Atlanta, located just a few miles outside the city, it's very much its own town. With a bustling town center filled with shops and restaurants, Decatur is also not lacking in bookstores. With several to choose from, what sets Brave & Kind Books apart? It is the diversity readers will find in almost every book the store stocks. "Our

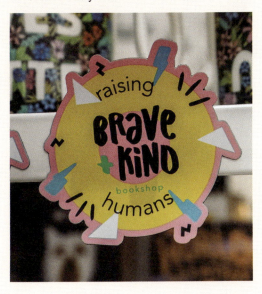

mission is representation and intentionally celebrating books with main characters and authors of color," shared Bunnie. "The neighborhood really showed up. They donated time, as well as to the crowdfunding campaign. They were excited to welcome Brave & Kind into the space, and it was Decatur friends and residents who came in and helped me paint the walls and paint the Brave & Kind logo on the wall and put the shelves together. It really was a community effort," said Bunnie.

GIVING BACK TO YOUR COMMUNITY

Bunnie merges her love of diverse literature and her community by working with a few different larger school programs that create libraries for Georgia. One organization is called the Rollins Center for Language and Literacy. "They have been tasked with building curriculum and libraries for fifty preschools not very far from here with an intention to be diverse, inclusive, and show representation in the stories that they share, which is right in line with our mission; to plant those seeds very early on. [We want to show children] that this is what the world should look like. And these are the people that we want to raise and be in the world. I think the more we present the stories in that way, [we can] normalize seeing and being with people of color, or people who may look different from you, or whose family may look different from yours in one way or another. I like to refer to it as putting

HOW TO GET INVOLVED WITHIN YOUR OWN COMMUNITIES

Attend the meetings that cultivate social and community awareness.

Become a Scout leader, with a focus on community service within your town.

Seek out nonprofit groups that are looking for volunteers; get the whole family involved in service days.

Organize a town-wide litter pickup, encouraging families to come together to clean up the streets.

Together with a church or other house of worship, start an after-school tutoring service for the local school.

Start a giving box, much like a little free library, that is stocked with nonperishables for those families in your community that are in need. Encourage the community as a whole to help stock it.

Start a culture crawl, whether for art, shops, or restaurants, and encourage the community to join in and shop small.

the broccoli in the pancakes. We love pancakes. Pancakes are delicious. But let's put this important stuff that you need in the pancakes too, so that you get to enjoy them and also get the benefit of the broccoli," remarked Bunnie. Working with several other nonprofit organizations in the area, Bunnie helps procure and distribute books to the schools.

RECOGNIZING THE DIVERSITY OF A TOWN

"What I noticed about the city of Decatur—and it does come from the town—is that [people here] make a concerted effort to do events that highlight the diversity in the community. Everyone shows up; they just do. And I have a lot of respect and appreciation for that," expressed Bunnie.

With lots of festivals that represent the diverse composition of the town, Decatur is working hard to give different communities fair representation. From festivals based around Indian cultures to Latinx ones, the varied ethnic communities that are represented in Decatur are celebrated. When you are looking for your own town, researching how the town supports and encourages diversity is important. Think about ways you can make it a more culturally diverse and supportive place for everyone who lives there. Even in a politically liberal town, it's important to recognize diversity and look for ways to make sure everyone who lives there is supported and that it's a safe environment for all.

DECATUR, GEORGIA

POPULATION: a little over 24,500

CLOSEST INTERNATIONAL AIRPORT: 17 miles to Atlanta

CLOSEST LARGE CITY: 7 miles to Atlanta

FESTIVALS NOT TO MISS: Decatur Arts Festival, Summer in the City, the Decatur Book Festival, the Decatur Makers Faire, the Decatur Craft Beer Festival, the Decatur Wine Festival, and the Decatur BBQ, Blues & Bluegrass Festival

Decatur is a large small town and fits well for those looking to have an urban feel from their small town choice.

Famous people who have called Decatur home include Chris Tucker, Michael Stipe, and Jan Hooks.

Agnes Scott College, a small, women's liberal arts college, sits in the heart of the town.

You can find Bunnie at @braveandkindbooks on Instagram.

EAST

MIDWEST

SOUTH

WEST

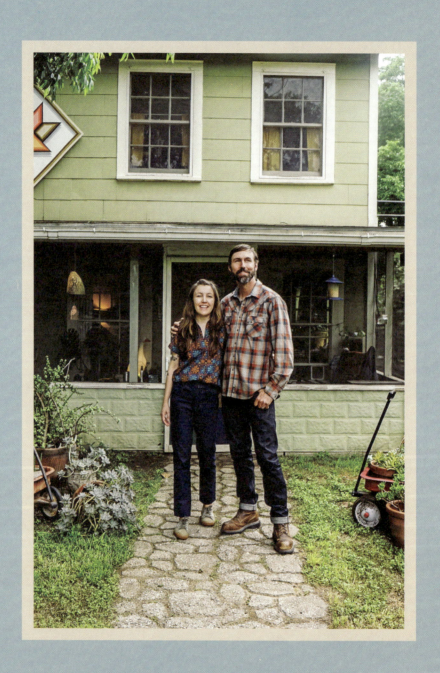

HEATHER SUNDQUIST HALL
AND MICHAEL HALL

Artists

SMITHVILLE, TEXAS

"There seems to always be something small happening to look forward to out here, which is always the right amount of something."

HEATHER SUNDQUIST HALL

Heather Sundquist Hall and Michael Hall, both fine artists, first met while they were living in Philadelphia. Later, they relocated to Austin, Texas. As Austin began to get more congested, they slowly began inching their way out of the city. First they moved to Webberville, about fifteen minutes outside of Austin. But as the couple became more comfortable with not being in the city proper and continued to long for more space, they moved farther and farther from the city. For the last five years, they have called the town of Smithville, Texas, about forty miles east of Austin, home. Even with people fleeing Austin to the surrounding small towns, Smithville has been able to hold steady at a population of roughly 4,000 people for the last fifty years.

As a former passenger railroad town, and with the introduction of a highway that bypassed Smithville, the town has skirted the explosive growth that other nearby towns have experienced over the last few years. Instead, people fleeing Austin have been moving to Bastrop, the next town over, because it's a much larger small town.

THE LIFE OF A COUPLE OF ARTISTS

Michael and Heather tend to keep the same schedule. They begin each day by walking their dog around the town, then get started on their respective art businesses. One might need to run to the post office while the other has a show to get ready for. Or Michael, who does a lot of mural work, might be working off-site for the day. While each day is different in

that respect, each evening sees them winding down with another dog walk before cooking dinner together.

Heather, who was a preschool teacher before she decided to take her art business full-time, felt the career move was a natural progression. Self-imposed deadlines have given her more time to focus on a piece of work, and she has learned to pace herself, living a little longer with a piece as she strengthens her artistic practice. Being in a small town has given both Michael and Heather more time to think, be with nature, and find inspiration in the quietness.

When Heather needs to regroup, she hops in the car and drives for twenty minutes, opening herself up to so much more inspiration for her art. She loves to blend nature with old, dilapidated buildings and cars in her paintings. She is fascinated by things that are falling apart or forgotten. "The pace is slower in Smithville and I think that's more conducive to creativity for the both of us," said Heather.

DECIDING ON WHERE TO MOVE

Michael and Heather spent time visiting Smithville before moving to town. They would come out for the day to walk around or have lunch. During those visits, they wanted to get a feel for the town and see if it was the right fit for them before jumping into another move. They quickly found that Smithville had a pretty big art scene, and they could really start to

see themselves living there. "We were looking for something that was not going to grow to an insane size so that we wouldn't be able to afford our mortgage. We could have affordable housing but also had cool little things happening [in Smithville]," shared Heather.

Smithville seemed to check all the boxes, with art crawls, backyard open mics, a main

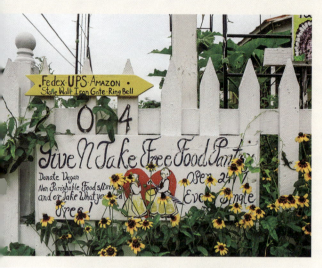

street with galleries and a playhouse, and a community of working artists. For a town the size of Smithville, the initiative for artists is encouraging. From help with grant writing to art markets to workshops, the town is supportive of all the artists who decide to live there, generating the sort of community that creatives are so often seeking.

Heather's move to Smithville felt like a clean break from Austin. And as much as she loves to get back there for live music and to visit old haunts that the couple still loves, at the end of the day, when she can leave the chaos behind her and embark on the beautiful drive back to Smithville, she knows she made the right decision to buy a home in a small town. "It might be stormy or it might be a sunset, it might be blue sky—who knows, who cares? You're coming home," remarked Heather.

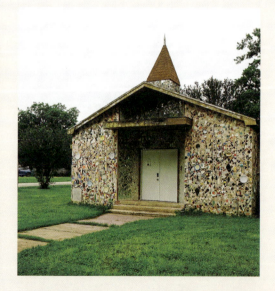

SMALL TOWN LIVING

WAYS TO ADD TO YOUR SMALL TOWN THAT WILL ENHANCE THE COMMUNITY

Work with the Main Street association, Chamber of Commerce, tourist bureau, or local garden club to plant a superbloom in a location where everyone can enjoy the flowers but it also serves to draw in tourists.

Work to have movies in the park. You could construct a simple screen with plywood painted white and a stand for it. Encourage people to bring chairs and takeout meals from local restaurants, or have food trucks on-site for a town-wide event.

Have a studio art crawl, in which the local artists and galleries open their spaces so that attendees can wander from place to place. If it's hot out, print the map of locations on a paper fan to distribute for the evening.

If you live in a waterfront town, start a river business for the canoe and kayak community, since so much river access tends to be only through private property. If your town isn't waterfront, consider starting a similar business with bicycle rentals.

Create a free clothing bin. Each week, locals can drop off washed clothing, still in good shape, and organizers can sort it into bins labeled by size. This could also include used sports equipment and backpacks.

Start a little gallery, much like a little free library, with small works of free art and rotating "exhibitions." A QR code can help people find the artist who is showing each time.

Design town merchandise for shops to sell: hats, tote bags, shirts, stickers, etc.

SMITHVILLE, TEXAS

POPULATION: a little over 4,000

CLOSEST INTERNATIONAL AIRPORT: 40 miles to Austin

CLOSEST LARGE CITY: 45 miles to Austin; 106 miles to San Antonio; 121 miles to Houston

FESTIVALS NOT TO MISS: The Smithville Birdfest in October, the town-wide Airing of the Quilts in November when people bring their quilts outside while a street market takes place, and a Festival of Lights and holiday parade in December when the town turns into a veritable Hallmark movie

Shows and movies film in Smithville so often that the town keeps a strip of downtown empty to act as a clean slate for the next film that comes along. Some works of note are *The Walking Dead, Panic, Tree of Life,* and *Hope Floats.*

Free jazz musician Hannibal Lokumbe was born and raised in Smithville.

You can find Heather and Michael at @heathersundquisthall / @mmmwhhh on Instagram.

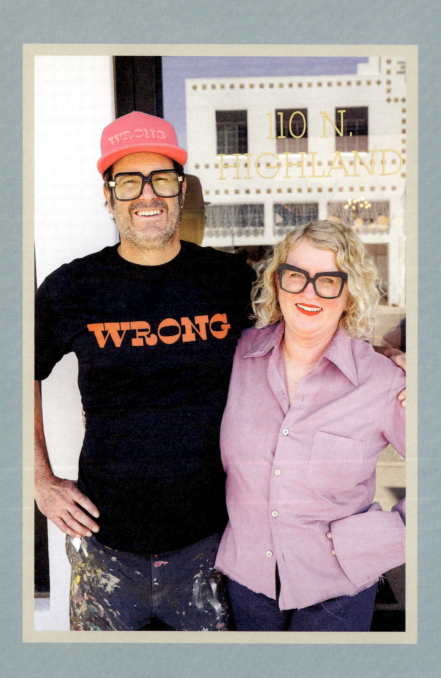

CAMP BOSWORTH AND
BUCK JOHNSON

Artist and Gallery Owners at Wrong Marfa and Do Right Hall

MARFA, TEXAS

"Our life in Marfa is charmed. We moved to this town of 1,700 people and our world expanded."

BUCK JOHNSON

It's hard to imagine a tiny town that's rather difficult to get to, in the middle of the West Texas desert, as an art mecca. But that's exactly what Marfa is, both to the art world and to a portion of the population that lives there.

When the renowned minimalist artist Donald Judd decided to move to the town, other artists followed, and they've been following ever since. This includes Camp Bosworth and Buck Johnson, who moved to Marfa in 2001.

The couple first met while living in Dallas after college. Camp had a successful art career based in Dallas, but shortly after they started dating, they took a road trip through the West Texas region and what was supposed to be a quick drive through Marfa. The couple passed through town during the Chinati Foundation symposium weekend. Camp and Buck were swept up in the allure of the town and the hustle and bustle of the symposium. They found that in Dallas, they were eating in the same five restaurants, frequenting the same five bars, and feeling somewhat stagnant. They were ready for a change. Their pass through Marfa set the course for the next chapter of their lives. The couple bought their home that same weekend and moved to Marfa four months later, never looking back. "It was the most spontaneous decision I've ever made, but also the most wonderful decision I've ever made," shared Buck. "Yeah, I've debated more on what kind of toothpaste to use over whether to move here," added Camp.

"We love the landscape [in Marfa]. You have to love the landscape to live here. And

we bought this great compound, an adobe church," shared Buck. The couple turned the former church into their home, an art studio for Camp, and a gallery space for visiting artists. Camp grew up in a small town as well, so falling back into the routine of one was really quite easy.

WHEN YOU HAVE TO FIGHT THE DESIRE FOR FLIGHT

When Camp and Buck first moved to Marfa, its art scene hadn't blossomed outward in the way it has in the years since. Camp often wondered, *What have I done?* While the couple has since settled joyfully into their life in Marfa, those first few years were hard on each of them.

Camp really wanted to be out of the city—any city. Doing so allowed him to stop thinking about the art he *was* creating and instead focus on the art he *wanted* to create. The move from Dallas to Marfa afforded Camp the freedom

to shift his practice from a more commercial direction to one focused on fine art.

In those first few years, there wasn't a lot going on in town. There was a Dairy Queen, but not much else. Now you can find local shops, world-renowned galleries, incredible restaurants, and lots and lots of artists.

IT'S HARD TO NOT THROW IN THE towel early on in your small town journey, especially because growth in these places often moves at a snail's pace. Remember that people don't move to a small town to recreate their city life, but to escape it. While it's great to have some aspects of city life in your town, it's not what everyone wants. Embrace the slow pace and understand that most people moving there want similar outcomes, but it takes time to do things the right way.

FEELING WELCOME IN YOUR NEW COMMUNITY

The hardest part about leaving Dallas for Camp and Buck was leaving behind the family of friends they had gathered over their ten years in the city. As a result, finding friends in Marfa was an important step for them. The Marfa locals took them under their wings and welcomed them to town almost instantly. "It's a small town. So you run into everybody a bunch of times, and you just can't help meeting locals. You're just going to run into them. And actually, the locals were quite welcoming. 'Hey, welcome to Marfa. We're so glad you're here,' we would hear from people who were born and raised here or had lived out here a long time who are like locals," shared Camp.

"Someone told us early on that the most important thing [to remember here] is you've got to be nice to everyone, because everyone is related. You cannot be a newcomer and walk into City Hall mad because your electricity hasn't been turned on yet. Because that person that works in that desk could be married to somebody in the electric company. Just be nice," recalled Buck.

Camp and Buck feel the same warmth when they return from a trip. Everywhere they go, once they've been gone for a week or two, people welcome them back. It further seals their love for Marfa.

THERE'S A DISTINCTION BETWEEN *local* and *newcomer*. **For example, Camp and Buck have lived in Marfa since 2001, but they still call themselves newcomers. Locals are those born and raised in the town. Many locals in small towns take great pride in being locals. If you're thinking of moving to a small town, it's best to understand the difference between the two terms.**

WAYS TO VOLUNTEER YOUR TIME IN SERVICE TO YOUR COMMUNITY

Run for office, city council, school board, etc.

Join the arts council.

Volunteer your time for events happening on Main Street.

Join the PTO (Parent Teacher Organization). You don't have to be a parent to join, nor have a child at the school.

Help out at the food pantry or community fridge. If your town doesn't have one, look into starting one.

Coach a local sports team for children.

Start a tutoring program for local children.

Start or join a small business incubator program to help businesses get their start.

If you are a retired person and know how to do basic plumbing and electrical, offer a small class to teach these skills to those who aren't as handy.

WHEN THE TOWN DECIDES YOUR FUTURE

Buck never intended to have a gallery and storefront, but after feeling burnt out from running the media company she had started before moving to Marfa, she was encouraged to open a store by a friend. And so Wrong Marfa was born. At the time, Camp was amassing piles of art that he'd never shown before, and their home had a natural location for the store in the former church's sanctuary. Running Wrong became Buck's day-to-day responsibility. They couple thought that if they made just $1,000 a month and kept the hours they wanted to be open, then it could be a nice little side business for them. In a small town, this kind of flexible, low-pressure mindset is entirely doable.

Little did they know how successful their venture would be. They've since moved the Wrong Marfa gallery into a 2,000 square foot location on the main street in town, Highland Street, where they show work from artists across Texas and beyond, alongside art and design books, jewelry, and more. Their former Wrong space is now home to the Do Right Hall, a place that serves as an artist residency space as well as a gallery for visiting artists.

SOMETHING TO KEEP IN MIND WHEN visiting Marfa—or most small towns for that matter—is that you'll need to plan accordingly. Many small town businesses are closed several days of the week and you want to make sure you get the full experience of a bustling day in town, if possible.

A PEEK BEHIND THE CURTAIN

Just before the pandemic in 2020, Buck ran for City Council and won. Especially because her term coincided with the pandemic—and all of the big needs and questions it gave rise to— she was able to learn so much about the inner workings of the town and ways to better serve their community moving forward. "You learn the ins and outs. And it's so interesting being on the other side. It does weirdly change your perspective. It was a fascinating study. It was awesome, but great and hard," shared Buck.

SMALL TOWN SCHOOL SYSTEMS

Something that so many small towns face is a lack of funding for the local public school system. Without adequate funds, the schools can't offer the same level of education as those in towns with a larger population. Because of this, families will often move to a small town and live there until their children are around five or six, then move somewhere else for their children to attend a better school.

Marfa is not immune to this problem. Tourists are great, but having people come to Marfa and stay is what will really allow for improvements to the schools. This is a countrywide problem in the United States.

MARFA, TEXAS

POPULATION: a little over 1,700

CLOSEST INTERNATIONAL AIRPORT: 194 miles to El Paso

CLOSEST LARGE CITY: 190 miles to Midland; 194 miles to El Paso

FESTIVALS NOT TO MISS: Marfa Invitational Art Fair, Marfa Lights Festival, and Chinati Weekend

Demographically, Marfa is 68 percent Latinx. All the members of the city council, the mayor, the police, and most of the city officials are Latinx. The town is much more than an art world destination, even if it is often thought of that way by outsiders.

Look for the Marfa Lights. These lights were first reported in 1883, and their source is still unknown.

Big Bend National Park is nearby and a big influence on Marfa.

Bonus towns nearby are Alpine and Fort Davis.

Visit Camp and Buck at wrongmarfa.com or find them at @wrongmarfa on Instagram.

SARA BUSCAGLIA

Farmer, Author, Quilter, Crafter, Artist

DURANGO, COLORADO

"Once we started farming, [it became] such an anchor, that you just can't leave. You just have to accept that and not even dream about being able to leave. So once we decided to farm, we were in it. I think we were really lucky because we were able to buy a place here before it got crazy expensive. We bought our farm almost eighteen years ago. Now it's just incredible. I think just getting in early for us was how we were able to do it. It was really, really hard at first, for the first five years or something. [We were] building up the infrastructure around the farm and working more than full-time throughout all that. But now we're just in a good place with it all. And yeah, we just talked about, 'Where would we go?' you know, if we wanted to leave here, but we're so set up here with our studios and the farm, and I don't think we'll probably ever, ever leave."

SARA BUSCAGLIA

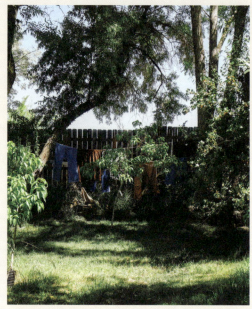

Sara Buscaglia and her husband Tom moved to the small town of Durango, Colorado, in 1997, before the widespread in-home use of the internet or social media, to create a very different world for themselves than the ones in which they were raised. Sara grew up just outside of Detroit, while Tom is from outside of Chicago. Neither had any farm experience other than a small garden in the yard. "My husband did have a garden growing up, so I guess he had that little experience of planting things and seeing the magic happen. I think it was probably his whole idea to grow a garden. We did and then the next year, we grew a bigger garden, and then we just fell head over heels for it, really. We had both dropped out of college after a couple years, so we were looking for what we were gonna do with ourselves. And gardening was really the only thing that we felt passionate about, so we just went for it," shared Sara. After a couple years of trial and error, in 1999 the couple set up their first farmers market booth, which they ran for the next fifteen years. During that time they also had four children, making the farm truly a family adventure, as they learned the ropes of farm life alongside the new world of homeschooling and running a working agricultural concern. "I have no regrets on doing it. But looking back, I'm like, 'How did we do that?' It was a lot," expressed Sara about those first fifteen years. "There are so many more resources and so many different things [available today], not just about homeschooling, but for art, farming, and everything. The internet is amazing."

THE POPULARITY OF HOMESTEADING ON THE RISE ONCE AGAIN

With the rise of homesteading in the United States, which was first popular between 1862 and 1934, people are once again looking to live off of the land as they create a more sustainable work-life balance for themselves. However, homesteading also comes with a lot of work that might not be immediately apparent to those on the outside. Sara offered this advice to someone who might be looking to start a farm, live off the land, and make their living off of the goods they produce: "Become an apprentice on somebody's farm—someone whose style of farming you admire, someone who has got it going on as a farmer—because farming is . . . a business. So find someone who is doing it and doing it really well. [At first] running it as a business was hard for us. We were just farming, farming, farming, and we didn't want to take on the business side. We just wanted the food to sell itself. We were so passionate about growing stuff that stopping to do the business part was really hard. So if you could take on an apprenticeship with someone who's doing it and successful—there's so much value in that. And also . . . come up with a timeline. I feel like sometimes the hardest part is making a plan. And then maybe the second-hardest part is actually following through with the plan or having the courage to, to jump," said Sara.

PIVOTING INTO A NEW CREATIVE DIRECTION

Sara and Tom eventually left market farming behind and were able to transition into a

IMPORTANT THINGS TO THINK ABOUT BEFORE BECOMING A HOMESTEADER

Will I rely just on the land or on outside resources as well?

How will I learn to grow my crops?

What space is needed to preserve my food?

How will I find my land?

How will I teach myself to build my home, outbuildings, etc., and maintain them?

What will be the conditions for raising livestock, and what care will they need?

What equipment will I need for a successful homestead?

How can I reuse, recycle, and repair around the farm?

How will I pay for this farm before it starts to make me money?

Which homestead environment is right for me? Urban, suburban, rural, or off-grid?

What are some alternative ideas that could save me a lot of money?

What are my long-term goals? What systems need to be put into place to succeed and meet my goals?

How tethered do I want to be to a place?

What is my expected timeline for my farm? Do I have years to invest, or should I look for a farm that has the infrastructure already in place?

full-time creative farm life. They now run a market stand from the foot of their farm, with a self-serve system, and they started a natural dye plant garden that formed a natural extension of Sara's artistic path. With the knowledge that she would one day want to pursue natural dyeing, Sara prepared ahead of time, planting a lot of madder root back in 2017. "You have to wait at least three years before you can begin kneading it, so that one is a special kind of cherished dye, because of all that work you put into it and all that waiting. And I love the red color that it gives and the pinks that it gives. There's a sunflower variety, the Hopi BlackBerry sunflowers. I love growing those, which make this sunshine yellow that I love to use in my work. . . . The dyes are kind of newer to me. I did all kinds of different flowers this year. I was picking flowers all summer. And it's all just fun. I think every year I'll just

keep expanding on and trying different things and see what ends up being my favorite and the most logical to grow too," expressed Sara.

CREATING A LIFE FOR THE NEXT GENERATION

Raising children in a small town can be tricky. Of course, you want them to experience the world around you and to encounter new things. At the same time, you want to create a place where they can find comfort and envision a life for themselves. Balancing the two is so important. Sara and Tom have done just that. Now that their children are older, in their twenties and teens, they are quite happy in Durango. Surrounded by much smaller mountain towns, Durango doesn't feel as limited as outsiders might perceive it to be. It has all the family needs and wants. Some of their children are interested in glassblowing, so Sara and

Tom built a studio on their three-acre farm. A home studio was set up for another child who is interested in music. The children, who have worked on the land since they were young, love the farm life they've been raised in. "When the kids were young, we had such a good, tight-knit community. I had a few great girlfriends, and we just raised the kids all together and we helped watch each other's kids. All our kids were born at home, and we were all with each other for all the births. We were just always together. When we were market farming, every Friday was harvest day. So all those friends would come and help, and the kids were just like a pack that was always running around the land or swimming in the pond," recalled Sara.

HOW TO LOCATE AN UP-AND-COMING SMALL TOWN WHERE YOUR DOLLAR WILL GO FURTHER

Look for a town near a college or university that is growing quickly, but where house prices are still lower.

Research how the price per square foot has changed in the last five years.

What is the job rate in the town? Is it going up or down?

Is it under an hour from a major city or airport?

Where are the artists moving? They usually have their thumbs on the places that are the next hot location to relocate.

How are the schools? Are they making strides to improve the current ratings? How involved are the parents in the community school?

What are the services the town provides? Will you have to drive out of town for provisions and health-related needs?

What's the turnover of housing? Do people live there for many, many years once they have a house or are homes always for sale?

DURANGO, COLORADO

POPULATION: a little over 19,000

CLOSEST AIRPORT: 15 miles to Durango-La Plata County Airport

CLOSEST LARGE CITY: 215 miles to Albuquerque, New Mexico; 337 miles to Denver; 392 miles to Salt Lake City, Utah

Durango gets sun 300+ days a year, with an average summer temperature around eighty-five degrees. Even in the winter, the sky is blue and sunny with an average temperature in the mid-twenties. These perfect weather conditions are due to the location. Durango sits in between the high desert and a high-alpine range.

You can find Sara at @farmandfolk on Instagram.

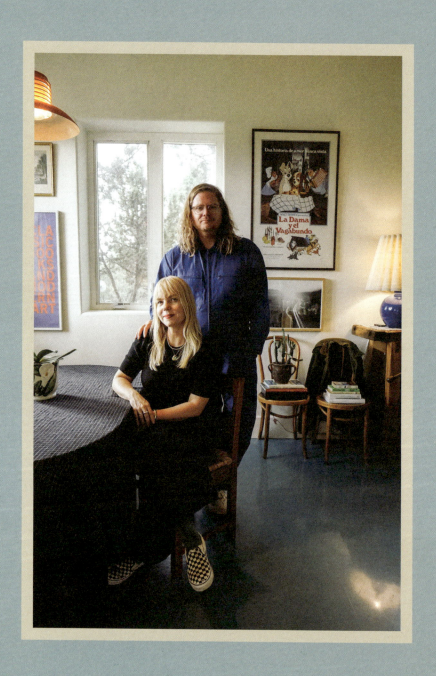

KIRK AND EVA JORGENSEN

Videographer, Travel Company Owner, and Author of
Paris by Design

HEBER CITY, UTAH

"Since there are not as many events and reasons to go out at night in small towns, you allow yourself to get comfortable being at home and doing your own thing, as opposed to [feeling the need to go out like] in a city. You can focus more on what you really want to be doing, as opposed to feeling distracted and pulled to go to several different things a night, every night."

EVA JORGENSEN

Rattling off all the places that Eva and Kirk lived growing up is like going through a who's who list of cities. Eva, who was born and raised in California, moved around Southern California a lot as a child and lived in places like Torrance, Redondo Beach, San Pedro, and Ranchos Palos Verdes. Her family moved to Park City, Utah, while she was still in high school, and she stayed there for college. Kirk's dad was in the Coast Guard and moved the family across greater distances, from Groton, Connecticut, to a town just outside of Boston, Massachusetts, and then to Northern California. After that, the family headed east again to Maryland, then back to the West Coast to Oakland, California, before finally landing in Oklahoma. Kirk then found his way to Utah, as well, also for college.

The couple crossed paths at Brigham Young University in Provo toward the end of their four years of school. Each had gone to Europe to study for a while—Kirk in Russia and Eva in France and Belgium. It wasn't until a college party—accompanied by a nudge from Kirk's sister—that the two met and knew almost instantly they had found the one. They were married seven months later.

As a married couple, they moved to Columbus, Ohio, for Kirk's graduate studies at Ohio State. There, they started their stationery business, Sycamore Street Press, which they ran from 2007 to 2017.

By this time, Eva's parents had bought a nice piece of land in Heber City, Utah, and the couple was beginning to discuss having children of their own. The idea of being in

close proximity to family during such a big life change was enticing, so once again, they packed up and made the cross-country move back to Utah where they met and where they still live today with their two children Ingrid and Lars.

PROFESSIONAL PIVOTS

At various points, Kirk and Eva both thought about teaching at the collegiate level, but because of the 2008 recession, Eva pivoted and began working on her letterpress stationery line full-time. Kirk then changed course, as well, and joined her. They were able to turn their garage, which is on the same property as her parents' home, into a full working studio for their creative efforts.

When they decided to close the stationery business in 2017, they both shifted into the role of creative director, with Eva creating concepts and Kirk filming the productions. When the world shut down due to the pandemic, that business too had to shift. Kirk was able to transition to a video production business. He works as a video creator, TV camera operator, TV producer, and creative producer for brand shoots to round out his freelance business.

And Eva, who wrote the travelogue *Paris by Design*, was able to turn her book into a full-time travel business. Now she leads small group trips, centered around art and design, throughout France. Both still work full-time from their in-house studio, which is just off their foyer.

Working side by side for so many years, the two fully understand one another's needs. And they allow themselves midday walks in the woods surrounding their property almost daily, just to regroup and refresh their minds.

It's on these walks that Eva does her best creative thinking, just by clearing her mind and leaning into new ideas.

WHEN A SMALL TOWN IS THE OBVIOUS CHOICE

At one time, before they landed in Heber City, Eva and Kirk thought about moving to Pittsburgh. The city was inexpensive at the time and offered a lot of grants for creatives to move there, but ultimately it didn't win out over Utah.

The couple also rented an apartment in Brooklyn for a month to see what living there with their stationery business might feel like and if a move to the borough might work for them. They quickly realized that having all their physical inventory in their studio apartment didn't make sense, so they returned to Heber City.

After closing Sycamore Street Press and while working together as creative directors, the couple started to plan to move the family abroad to Paris. Everything was falling into place, and Eva's dream of her children going to public school in France, where they could be

immersed in the language, was all working out. And then the pandemic happened. The creative director business took a pause, and moving to France was put on the back burner. And once again, staying in Heber City became a really fantastic plan for the couple, while they figured out what to do next. "It was a rough couple of years, but it ended up being the best because we were both able to pivot and come out in a place where we're doing work we love even more and that we're even more passionate about. So it ended up being a blessing in disguise," said Eva.

CREATIVITY IS BETTER IN NUMBERS (AT YOUR OWN PACE)

While almost all her creative endeavors take her away from Heber City, Eva still saves some of that creative energy to share in a local art salon. She meets once a month with other freelance and creative mothers, and they take turns presenting what's going on with them lately. If someone has a question or a challenge they're going through with their creative work, they can bounce around ideas and get advice from the others in the group. Eight years later, the group is still going strong.

Inspired by the art salon, Eva hopes to one day expand on the group to include the community in a themed movie club. She would love to rent out the local one-screen movie theater to show an interesting film, which the club can then discuss, sparking more conversation around the art of film within her community.

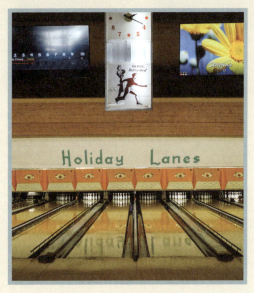

WAYS TO REGROUP, RECENTER, AND REST WHEN WORKING FROM HOME AND WORKING FOR YOURSELF

Take daily nature walks; use them as time to get inspired and think up new ideas.

Ground yourself in the grass every day for twenty to thirty minutes.

Add a practice of yoga or meditation into your day. Even just ten minutes of either benefits your health and work.

Allow yourself time to meet a friend for coffee. The meeting doesn't have to take your whole day, but just checking in with another person is a great way to regroup.

Drink water throughout the day; make it sparkling or throw in some fruit if you get bored with still water.

Sleep on the job. Taking a twenty-minute nap can leave you refreshed and ready to carry on for a few more hours of work.

ONE THING TO KEEP IN MIND WHEN moving to a small town is that you might not find all your like-minded people right away. Living in a small town is putting yourself in for the long game. It might be years before you really have that community you are craving. And if you do find that community, remember that some people in it might live in a bonus town nearby and not right in the enclave where you are.

HEBER CITY, UTAH

POPULATION: a little over 17,200

CLOSEST INTERNATIONAL AIRPORT: 36 miles to Salt Lake City

CLOSEST LARGE CITY: 28 miles to Provo; 45 miles to Salt Lake City

FESTIVALS NOT TO MISS: Heber Valley Cowboy Poetry Festival, Swiss Days Festival, and Soldier Hollow Classic Sheepdog Festival

Heber City is a fast-growing town, with 4 percent growth every ten years.

Known for its natural beauty, Heber City is a wonderful place to live for year-round outdoor activities for the whole family, like skiing and hiking. With its proximity to Park City, though, Heber City is becoming an expensive place to live.

Skiing is offered through the local recreation center in Heber City.

Heber Valley connects several small towns together, including Heber City, Charleston, Whitesburg, and Midway.

You can find Eva and Kirk at @evajorgensentravel / @kirk.film on Instagram.

JOANNA HAWLEY-MCBRIDE

Content Creator and Business Strategist

SKAGIT RIVER VALLEY, WASHINGTON

"Every day is different, [and is] a combination of really, really hard work, like hauling firewood, or defrosting water for the geese or the chickens. [It's also] really, really fun to be two hours closer to all the stuff we love to do [outdoors]. I finally have a garden that is literally bigger than my old house [in Seattle], which was 640 square feet."

JOANNA HAWLEY-MCBRIDE

Just two hours north of Seattle, Joanna Hawley-McBride and her husband Sean, a boat mechanic, found a home in the rural country of the North Cascades. Landing in the Skagit River Valley in an unincorporated area with fewer than 350 people, Joanna has been able to streamline her work so that she makes more, yet works less. This allows her time to focus on her health, which inspired their move in the first place.

"I had a big health scare a few months prior to the pandemic, but I didn't get my diagnosis until March 2020. The timing of that was really intense. And I started to really feel my mortality, because I was in cardiac distress when I was hospitalized the week after our wedding. And so it was like, 'It might be time to make some changes,'" recalled Joanna

about the decision to move from Seattle to a small town.

She bounced around the country most of her life, living in places like Wyoming and Maryland as a child, working for Anthropologie as a textile designer in Pennsylvania, and living in California for a bit before moving to Seattle, Washington. It was there that Joanna met Sean, a lifelong Seattle resident.

A health diagnosis made moving out of the city a must for Joanna, and pushed the couple to take a step they had been contemplating for years prior. Both are avid climbers and would spend any chance they got in the North Cascades, looking for new places to hike, climb, and explore. The area that they had their hearts set on moving to at the beginning of their search is not where they ended

up, however. "We wanted to live in Mazama, which is on the other side of the mountain pass from where we are, but that pass closes in the winter because of avalanche danger. That would have made Sean's commute like six hours. [So we thought, if] we can't be on this side of the pass, we have to be on the other side. We could either go north or south . . . so we just kind of kept looking like up and down the highways [in the Skagit Valley until we found the place that felt right]," shared Joanna.

LEARNING HOW COSTS SHIFT SEASONALLY

When asked if there were things that they couldn't have dreamed of doing in Seattle that they are now able to do in their rural home, or if their costs shifted up or down, Joanna responded with, "It's really interesting, because it's actually both. We don't pay for water, and we don't pay for firewood. But at the same time, we pay for propane, which can fluctuate in cost, with fast shifts. But we're on our third year here, and we're learning seasonally where [our costs] shift. So, for example, our electrical bill for the summer was like $20 for two months. But in the winter, it might be $400. So it's really about [figuring out where] the dollars get spent. Our mortgage is half of what we were paying [in Seattle], so it's afforded us a lot of flexibility."

HOME MAINTENANCE QUESTIONS TO ASK BEFORE MOVING TO A RURAL AREA

Will I need a chimney sweep?

How's the internet connection?

What weather situations will I need to be aware of in this area?

Am I in a floodplain?

Does my water come from a well? Do the homes have their own septic systems?

Are there power outages? Are the power lines buried or pole?

Will I need to stockpile firewood or is it readily available?

Will I need to buy propane?

Does my land need things like a tractor or other heavy machinery?

FINDING YOUR PEOPLE IN A RURAL SETTING

Using social media for good, Joanna has been able to connect with her people through the Facebook community page. When someone was looking for a rug for their home and Joanna had an extra to spare, she reached out. "We met this woman at a gas station to give her a rug, and she had a dog with her and we had one of our dogs with us. They kind of played a little bit in the parking lot. We came to find out she's an employee of the national park. She lives in a house with seven other park employees. We somehow figured out that we were both progressive and had similar values. We're just on the same wavelength. We hung out all winter and would take the dogs to the creek. Through them, we've met more people," said Joanna.

Living in a small place isn't easy for everyone. If you are someone who thrives on social activity, think carefully about what type

of small environment you need to feel content. It's an important question, and not one to consider only after you've made your move. You might need a town with a larger population and with more services within walking distance. If you are okay with not seeing people often, or crave quiet and alone time, a more rural setting might be up your alley.

USING YOUR NEW ENVIRONMENT TO SPARK CREATIVITY

"I feel like I'm more creative, because I have the room to be creative, make a mess, and try something new. But also, if I'm feeling stuck, I go for a drive, go for a walk, go for a hike, go for a swim. I just bask in the fact that my day-to-day life is so different from everyone else's. And then, because I'm working a little bit less, I can take a day off if I'm feeling uninspired [without feeling like] I have to crank out whatever it is," said Joanna.

RECREATING WHAT YOU MISS ABOUT CITY LIVING

Many people who have made the move from city living to a small town remark how much they miss the diversity in the food they eat. Joanna has learned to adapt to the changes. "I've learned to be very good at making the things that I crave. I have a cookbook collection and [if I want] pad thai [I'm able to make it myself]. I have everything. I could make pretty much any Vietnamese or Thai dish [that you would find in a restaurant] or maybe Japanese and Indian as well. I have all the Mediterranean stuff. You have to be prepared," said Joanna.

PLACES TO LOOK FOR CREATIVE INSPIRATION IN A RURAL ENVIRONMENT

Find a road you haven't driven down before, play some good music, and see what it sparks in you.

Visit the local lake for a swim, feeling the cool water on your face, and thinking back to a time in your childhood when you found joy.

Find a new trail to hike, making note of the trees and the way the light moves through the branches.

Find a wild berry patch, pick some berries, and make a pie from scratch.

Have a picnic, taking time to just lay in the grass and stare at the clouds.

Work in the garden, feeling the dirt in your hands.

Ground your feet in the grass.

SKAGIT RIVER VALLEY | NORTH CASCADES, WASHINGTON

POPULATION: Through a series of individual small towns, the population is around 130,000 for the whole valley. Joanna and Sean's town is around 350 people.

CLOSEST INTERNATIONAL AIRPORT: 115 miles to Seattle

CLOSEST SMALL CITY: 65 miles to Bellingham

CLOSEST LARGE CITY: 101 miles to Seattle

CLOSEST NATIONAL PARK: 15 miles to the North Cascades National Park

Some of the small towns in the valley are Concrete, Marblemount, and Rockport.

With a focus on the outdoors, this area is full of trails to hike, rivers to explore, and camping. Just remember that, in the winter, snow can close down certain routes, making for a very long travel time to get where you are going.

Ross Lake is a not-to-miss landmark in the area. Its stunning blue water is breathtaking.

You can find Joanna at @jojotastic on Instagram or visit jojotastic.com.

DANIELLE KRYSA

Creator of the Blog *The Jealous Curator*, Fine Artist, Author

SUMMERLAND, BRITISH COLUMBIA, CANADA

"When we moved back [to Summerland], my husband and I had been together for fourteen years. We've lived in Toronto and Vancouver together, and then we moved here. We'd maybe been here two weeks, and he said, 'I have never seen you this calm. You're just so centered.' And I think it's because when I lived in big cities, my brain never stopped. It was just like a constant buzz with thoughts of, 'Where are you going to park? You've got to leave an hour early because there's traffic.' All of these things. And here, there's none of that buzz. Here, there's nothing to think about. There's no traffic. There's literally nothing to think about. And so when we got here, I said to him, 'I think I've been exhausted for twenty years and I didn't know.'"

DANIELLE KRYSA

For many of us who grew up in small towns, we think, "As soon as I turn eighteen, I'm leaving this place and never looking back." And while that's the case for many, that wasn't so for artist, author, and creator of the blog *The Jealous Curator* Danielle Krysa. Still, when Danielle left Summerland, British Columbia, for college, she never would have imagined that she could have the life she dreamed of back in her hometown. She didn't know it yet, but her story would lead her right back to her roots.

"My heart was always here, but I worked in advertising. Back then, I thought I needed to be in a big center. In Canada, that was basically Toronto or Vancouver. And so I was in Toronto for ten years and then Vancouver for nine. But I kept wanting to get smaller. So we moved from Vancouver to Steveston. It's a really cute little town forty minutes outside of Vancouver. And that felt so much more like me, because it was small, but the city was close by, and my son was born there. [My blog] *The Jealous Curator* started there. [But] I still wasn't settled. I still thought that this is not where I want to be. But I didn't know where I wanted to be, because I thought I needed to be near a city."

It wasn't until Danielle's twenty-year high school reunion that she experienced the eureka moment. Driving into the valley of Summerland, she could feel her heart rate dropping. "It's just so peaceful here, and you come off the highway and you go around this bend and all of a sudden you're in the valley. . . . There's just something very magical about it," shared Danielle. It was on the drive home,

back to the Vancouver area, that her husband said, "What if we move to Summerland? We can pay Vancouver prices and work from home. Or we can move to this paradise and have a view of the lake and work from home." Danielle started crying, and that was all it took for the wheels to be put in motion. Their son Charlie was five and about to start kindergarten. They knew they needed to act fast before he established friendships and his own roots in Steveston. A year later, they were in their forever home. Charlie, now in high school, is centered around Summerland, attending the same high school whose reunion helped decide where he would grow up.

Summerland is a town with four distinct seasons, "each lasting exactly three months," remarked Danielle. This type of magic makes it a vacationland for many, with a population that doubles in the summer. The weekend farmers markets, the community-wide festivals, and the endless outdoor activities make it the type of place that would attract anyone. Danielle is charmed that Charlie attends the same festivals she grew up attending and finds a sense of peace and comfort in the mirrored childhood she shares with her son.

INTRODUCING THE INTERNET

"There was more of a sense of being isolated, growing up here, as opposed to now . . . when you get all the benefits of a small town, but then you get access to the world through the internet. It's a very different vibe than it used to be," shared Danielle.

Thanks to the internet, Danielle is able to write her blog and newsletter from anywhere in the world. She's also able to maintain friendships that she's made with people across the globe, staying in contact with people in Europe, the United States, and Australia. While the internet won't allow everyone to work from wherever they'd like, it has afforded that opportunity to Danielle and her family.

In the past, many small towns have served as retirement communities, leading to steady, incremental population growth. But now that so many people are creating jobs for themselves, thinking outside the box, and working remotely, small towns are seeing a boom that they haven't experienced before. It's up to the residents to help preserve the charm and appeal as they keep their small town, well, small.

PLACES TO LOOK FOR WORK WHILE LIVING IN A SMALL TOWN

Schools always need substitute teachers. This is a great way to also meet new people.

Your local library might need volunteers or part-time workers.

Check in with a bakery to see about being a shop assistant.

Find remote work or virtual employees in your field; turn to your colleagues for knowledge of remote work.

Look into the nearby college or university.

Look into teaching a class at the local arts council.

Visit your local tourism board or chamber of commerce to see if they might have any suggestions.

Work on a local farm or at a farm stand, or grow your own produce to sell.

Put your existing skills to work; for example, if you know how to make cabinets or furniture, give it a go as a full-time gig.

Offer your photography skills by taking family, graduation, wedding, or newborn photos.

Create a weekly nature walk for kids or adults.

Become a day laborer.

Work as a freelance writer, pitching to magazines or newspapers that cover the area where you live.

Work as a bookkeeper or help with tax prep work.

Learn a skilled trade and become a housepainter, electrician, plumber, etc.

Start a lawn care business.

GROWTH AFTER A PANDEMIC

Since the pandemic of 2020, people have been moving out of the nearby cities and finding their way to Summerland and the surrounding communities. This has added great restaurants and local shops to the area, which Danielle does not mind at all.

Since Summerland is a vacation destination, this type of growth doesn't trouble locals. But before setting up your own shop in a small town, it's important to recognize what the town needs. A few questions to ask are: *How will this serve the people who are already living here? Is this business inclusive to everyone or am I catering to the tourists? How am I contributing to my new community outside of my new business? And how am I maintaining the feeling of the small town by preserving the culture and helping to shape the landscape?*

WANDER-FULLY ROOTED

When asked how Summerland affects her creative process as a writer and a fine artist, Danielle said, "I think it's two things. I can breathe here. You know, if I'm feeling blocked, I can go for a walk and only look for wildflowers, and take pictures of those, and then come back. And even if I'm not doing anything with wildflowers, it's been that moment of just clearing the cobwebs and just taking a breath. Sometimes I go out and I look at the mountains on the other side of the lake. And I think, I am so small and this valley was formed like 500,000 years ago, when an iceberg pushed through and a volcano erupted. And it just makes you realize like, 'Okay, all of these problems are not really problems.' You know, all of this has been here and all of this will be here once I'm gone. I never had that in a city. In a city, I always

felt a lot more competition. There's always something happening in a city. I never had a moment to just let my brain rest."

On top of wandering in nature, Danielle can find peace in small town thrift shops. When she's feeling stuck, she can visit a thrift shop and not even buy anything. Instead, she'll just wander and find weird things. "I'll set a challenge for myself to only spend $2. I'll come out of there with my $2 worth of weird knick-knacks, and I come home and I force myself to make something with those weird knick-knacks. In a city I don't think I could buy a book for $2 in a thrift shop," she remarked.

Danielle's story took her from Vancouver to Nova Scotia, to Summerland, to Victoria, to Toronto, back to Vancouver, and finally back to Summerland, where she plans to live the rest of her life. While she loves to travel—and does so regularly—it's her small town that keeps drawing her back in.

SUMMERLAND, BRITISH COLUMBIA

POPULATION: a little over 12,000

CLOSEST INTERNATIONAL AIRPORT: 31 miles to Kelowna

CLOSEST LARGE CITY: 264 miles to Vancouver

Tourism, outdoor sports, wineries, and a vast amount of fruit farms are the cornerstones of industry in Summerland.

You can find Danielle at @thejealouscurator / @daniellekrysaart on Instagram.

FUN EXTRAS

SMALL TOWN BOOKSTORES THAT READ LIKE A BIG-CITY SHOP

The Book Barn Niantic, Connecticut

Brave & Kind Books Decatur, Georgia

Explore Booksellers Aspen, Colorado

Frenchtown Bookshop Frenchtown, New Jersey

Inquiring Minds Saugerties, New York

Main Street Bookmine Saint Helena, California

Maria's Bookshop Durango, Colorado

The Montague Bookmill Montague, Massachusetts

Rabelais Biddeford, Maine

Square Books Oxford, Mississippi

SMALL TOWNS WITH NATIONAL PARKS NEARBY

Bar Harbor, Maine Acadia National Park

Durango, Colorado Mesa Verde National Park (UNESCO World Heritage Site)

Gatlinburg, Tennessee Great Smoky Mountains National Park (UNESCO World Heritage Site)

Haines Junction, Yukon, Canada Kluane National Park (UNESCO World Heritage Site)

Jackson Hole, Wyoming Grand Teton National Park

Joshua Tree, California Joshua Tree National Park

Lee Vining, California Yosemite National Park (UNESCO World Heritage Site)

Moab, Utah Arches and Canyonlands National Parks

Paia, Hawaii Haleakala National Park

Port Angeles, Washington Olympic National Park (UNESCO World Heritage Site)

Whitefish, Montana Glacier National Park (UNESCO World Heritage Site)

UNIQUE BIKE TRAILS IN SMALL TOWNS

Cowboy Trail Nebraska

D & R Canal Trail New Jersey

Delaware Canal Trail Pennsylvania

Erie Canalway Trail New York

Harlem Valley Rail Trail New York

Katy Trail Missouri

Olympic Discovery Trail Washington

Tanglefoot Trail Mississippi

BEACH TOWNS THAT FEEL TIMELESS

Asbury Park, New Jersey

Cannon Beach, Oregon

Cape May, New Jersey

Charlevoix, Michigan

Chincoteague Island, Virginia

Daufuskie Island, South Carolina

Duck, North Carolina

Edenton, North Carolina

Kennebunkport, Maine

Key West, Florida

Makawao, Hawaii

Montauk, New York

Nantucket, Massachusetts

Ocean Springs, Mississippi

Pacific Grove, California

Petoskey, Michigan

Rockport, Texas

St. Augustine, Florida

Stinson Beach, California

St. Simons Island, Georgia

Westerly, Rhode Island

CHARMING SMALL COLLEGE TOWNS

Bath, Maine

Chestertown, Maryland

Danville, Kentucky

Gambier, Ohio

Hanover, New Hampshire

Malibu, California

Natchitoches, Louisiana

Newport, Rhode Island

Oxford, Mississippi

Port Townsend, Washington

Rochester, Michigan

Vermillion, South Dakota

Waterville, Maine

SECRET SMALL TOWN FOOD DESTINATIONS

- Aspen, Colorado
- Conshohocken, Pennsylvania
- Healdsburg, California
- Ketchum, Idaho
- Lake Chelan, Washington
- Mystic, Connecticut
- Oxford, Mississippi
- Saugatuck, Michigan
- Sioux Falls, South Dakota
- Tupelo, Mississippi
- Winter Park, Florida

BEAUTIFUL WATER TOWNS

- Alexandria Bay, New York
- Astoria, Oregon
- Avalon, California
- Block Island, Rhode Island
- Brookings, Oregon
- Friday Harbor, Washington
- Hood River, Oregon
- Jamestown, Rhode Island
- Ketchikan, Alaska
- Ladysmith, British Columbia
- Langley, Washington
- Mackinac Island, Michigan
- Port Townsend, Washington
- Sag Harbor, New York
- Saint Francisville, Louisiana
- Sanibel Island, Florida
- Sausalito, California
- South Bristol, Maine
- Tofino, British Columbia
- Tybee Island, Georgia
- Vashon Island, Washington
- Wellington, Ontario

LITERARY SMALL TOWNS THAT MAKE YOU WANT TO PICK UP A BOOK

Amelia Island, Florida

Big Sur, California

Carmel-by-the-Sea, California

Chelsea, Michigan

Concord, Massachusetts

Decatur, Georgia

Eatonville, Florida

Hobart, New York

Key West, Florida

Livingston, Montana

Oxford, Mississippi

Red Cloud, Nebraska

ARTSY SMALL TOWNS

Beacon, New York

Brattleboro, Vermont

Cody, Wyoming

Eureka Springs, Arkansas

Fort Bragg, California

Lake City, South Carolina

Livingston, Montana

Madrid, New Mexico

Marfa, Texas

Montpelier, Vermont

New Hope, Pennsylvania

North Adams, Massachusetts

Water Valley, Mississippi

Woodstock, New York

SMALL MUSIC TOWNS

Anacortes, Washington

Arcata, California

Brunswick, Georgia

Clarksdale, Mississippi

Muscle Shoals, Alabama

Oxford, Mississippi

Vermillion, South Dakota

Westerly, Rhode Island

Williamsburg, Virginia

Yellow Springs, Ohio

Ypsilanti, Michigan

CRAFT SCHOOLS THAT TRANSPORT YOU TO SLOWER DAYS

Arrowmont School of Arts and Crafts Gatlinburg, Tennessee

Augusta Heritage Center Elkins, West Virginia

B.A.R.N. Bainbridge Artisan Resource Network Bainbridge Island, Washington

Gee's Bend Quilting Collective Boykin, Alabama

Huck Finn School Sullivan's Island, South Carolina

Idyllwild Arts Idyllwild, California

Madeline Island School of the Arts La Pointe, Wisconsin

Marine Mills Folk School St. Croix, Minnesota

Ozark Folk Center Mountain View, Arkansas

Penland School of Craft Spruce Pine, North Carolina

Waterford Craft School Waterford, Virginia

WoodenBoat School Brooklin, Maine

FAMOUS SMALL TOWN HOUSES TO VISIT

John Brown (abolitionist) Osawatomie, Kansas

Alexander Calder (artist) Roxbury, Connecticut

Johnny Cash (musician) Dyess, Arkansas

Amelia Earhart (explorer) Atchison, Kansas

William Faulkner (author) Oxford, Mississippi

William Randolph Hearst (publisher) San Simeon, California

Ernest Hemingway (author) Key West, Florida

Winslow Homer (artist) Scarborough, Maine

Glass House designed by Philip Johnson (architect) New Canaan, Connecticut

Georgia O'Keeffe (artist) Abiquiu, New Mexico

Jackson Pollock and Lee Krasner (artists) East Hampton, New York

Prince (musician) Chanhassen, Minnesota

John D. Rockefeller (businessman) Sleepy Hollow, New York

Theodore Roosevelt (former president) Medora, North Dakota

Mark Twain (author) Hannibal, Missouri

Edith Wharton (author) Lenox, Massachusetts

SMALL TOWN HOTELS

Bardessono Hotel Yountville, California

Black Spruce Whitehorse, Yukon

Camp Wandawega Elkhorn, Wisconsin

Captain Whidbey Coupeville, Washington

The DeBruce Livingston Manor, New York

Deer Mountain Inn Tannersville, New York

Dunton Hot Springs Dunton Hot Springs, Colorado

The George Montclair, New Jersey

Highlander Mountain House Highlands, North Carolina

Hotel Joaquin Laguna Beach, California

Hotel Millwright Amana, Iowa

Hotel Tupelo Tupelo, Mississippi

The Maker Hudson, New York

The Oliver Oxford, Mississippi

The Surf Lodge Montauk, New York

Thunderbird Hotel Marfa, Texas

Timber Cove Resort Sonoma County, California

Tourists North Adams, Massachusetts

Travelers Hotel Clarksdale, Mississippi

The Western Ouray, Colorado

Willow House Terlingua, Texas

MOVIES FILMED IN A SMALL TOWN

Astoria, Oregon *The Goonies*

Beaufort, South Carolina *The Big Chill*

Bodega Bay, California *The Birds*

Bozeman, Montana; Rural Wyoming and Montana *A River Runs Through It*

Brownsville, Oregon *Stand by Me*

Canton, Mississippi *Oh Brother, Where Art Thou?* and *My Dog Skip*

Corner Brook, Newfoundland; Fox Point, Nova Scotia, Canada *The Shipping News*

Dubuque, Iowa *Field of Dreams*

Gloucester, Massachusetts *Coda*

Greenwood, Mississippi *Mississippi Masala*

Lake Winnipesaukee, New Hampshire *On Golden Pond*

Manchester, Vermont; Peru and Weston, Vermont *Baby Boom*

Marfa, Texas *Giant* and *No Country for Old Men*

Martha's Vineyard, Massachusetts; Kure Beach, North Carolina *The Inkwell*

Monroe, Georgia *Hidden Figures*

Mystic, Stonington, and Pawcatuck Connecticut; Westerly, Rhode Island *Mystic Pizza*

Narragansett Bay, Jamestown, and Rockville, Rhode Island *Moonrise Kingdom*

Pioneertown, California over fifty cowboy films in the 1940s

Selma, Alabama; Covington and Rutledge, Georgia *Selma*

Senoia, Georgia *Fried Green Tomatoes*

Smithville, Texas *Hope Floats* and *Tree of Life*

Vernon, Texas *Hud*

Weirton, West Virginia *Super 8*

Wellesley, Massachusetts *Mona Lisa Smile*

TOWNS WHERE INDIGENOUS CULTURE IS CELEBRATED

Acoma Pueblo, New Mexico

Browning, Montana

Cherokee, North Carolina

Dawson City, Yukon

Hayesville, North Carolina

Ketchikan, Alaska

Nome, Alaska

Pine Ridge, South Dakota

Tahlequah, Oklahoma

BARS TO GRAB A DRINK IN A SMALL TOWN

Bar Muse Oxford, Mississippi

Barrel House Tavern Sausalito, California

BonTon & Company Dawson City, Yukon

Bread Bar Silver Plume, Colorado

1883 Tavern Athens, New York

Glorietta Jackson Hole, Wyoming

Grit Taylor, Mississippi

Queen's Reward Meadery Tupelo, Mississippi

Sullivan's Fish Camp Sullivan's Island, South Carolina

The Tap Room at the Griswold Inn Essex, Connecticut

Wonderbird Taylor, Mississippi

SMALL TOWN FESTIVALS TO VISIT

Barbecue Festival Lexington, North Carolina

Burlington Steamboat Days Burlington, Iowa

Double Decker Arts Festival Oxford, Mississippi

Festive Bastille Day Frenchtown, New Jersey

Florida Seafood Festival Apalachicola, Florida

Fountain Hills Great Fair Fountain Hills, Arizona

Juke Joint Festival Clarksdale, Mississippi

Kutztown Folk Festival Kutztown, Pennsylvania

Lilac Festival Mackinac Island, Michigan

Maine Lobster Festival Rockland, Maine

Marlboro Music Festival Marlboro, Vermont

National Cherry Festival Traverse City, Michigan

New Hampshire Pumpkin Festival Laconia, New Hampshire

Newport Winter Festival Newport, Rhode Island

Oregon Shakespeare Festival Ashland, Oregon

Steamboat Springs Winter Carnival Steamboat Springs, Colorado

Strawberry Festival Vashon Island, Washington

Texas SandFest Port Aransas, Texas

Watermelon Carnival Water Valley, Mississippi

Wellfleet OysterFest Wellfleet, Massachusetts

Wilder Days Mansfield, Missouri

SMALL TOWN FILM FESTIVALS

Ashland Independent Film Festival Ashland, Oregon

Beaufort International Film Festival Beaufort, South Carolina

Camden International Film Festival Camden, Maine

Martha's Vineyard African American Film Festival Martha's Vineyard, Massachusetts

Mill Valley Film Festival Mill Valley, California

Nantucket Film Festival Nantucket, Massachusetts

Napa Valley Film Festival Napa, Yountville, Calistoga, and St. Helena, California

Sundance Film Festival Park City, Utah

Telluride Film Festival Telluride, Colorado

Whistler Film Festival Whistler, British Columbia, Canada

SMALL TOWNS WITH A BIG HISTORY

Atlantic Beach, South Carolina

Clarksdale, Mississippi

Dawson City, Yukon, Canada

Galveston, Texas

Highland Beach, Maryland

Oak Bluffs, Martha's Vineyard

Oxford, Mississippi

Poulsbo, Washington

Sag Harbor, New York

Sitka, Alaska

St. Helena Island, South Carolina

Sullivan's Island, South Carolina

Taos, New Mexico

Williamsburg, Virginia

WHAT'S THAT TOWN KNOWN FOR?

Dawson City, Yukon, Canada The Klondike Gold Rush

Marfa, Texas Donald Judd and the Chinati Foundation; Prada Marfa

Moab, Utah The base for not one, but two national parks

Selma, Alabama The start of the Selma to Montgomery marches of 1965

Silver Plume, Colorado Bread Bar, made popular by Instagram and rightfully so

Taos, New Mexico Taos Pueblo (UNESCO World Heritage Site) and Georgia O'Keeffe

Toadlena/Two Grey Hills, Navajo Nation, in state of New Mexico Diné Skate Garden Project

Williamsburg, Virginia The first planned city of the United States

REGIONAL FOOD AND BRANDS
WORTH THE DRIVE

Biscochitos New Mexico

Blue Bell ice cream Texas

Burgoo Kentucky

Cheerwine North Carolina

Chislic South Dakota

Dr. Brown's soda New York

Duke's mayonnaise South Carolina

Fried cheese curds Wisconsin

Hatch chiles New Mexico

Hoosier pie Indiana

Juanita's tortilla chips Oregon

Key lime pie Florida

Kolache Texas

Kringle Wisconsin

Lefse Minnesota

Lobster roll Maine

Moon pies Tennessee

Moxie Maine

Muffuletta Louisiana

Pal's Sudden Service East Tennessee

Pepperoni rolls West Virginia

Runza Nebraska

Salt water taffy New Jersey

Smoked salmon Alaska

Spam Hawaii

Tabasco hot sauce Louisiana

Utz potato chips Pennsylvania

Zapp's potato chips Louisiana

SMALL TOWN SCENIC ROUTES

Alaska Highway Alaska to Yukon, Canada

Beartooth Highway Montana to Wyoming

Blue Ridge Parkway North Carolina to Virginia

Cades Cove Loop Tennessee

California State Route 180 California

Cascade Loop Washington

Coastal Connection Scenic Byway Alabama

Frank Lloyd Wright Trail Wisconsin

Going-to-the-Sun Road Montana

Great River Road Minnesota to Louisiana

Hana Highway Hawaii

Highway 82 Colorado

Highway 97 British Columbia, Canada

Highway 101 Oregon

Highway 138 Oregon

Highway 550 Colorado

M-22 Michigan

Natchez Trace Tennessee to Mississippi

North Cascades Scenic Highway Washington

Ohio Art Corridor Ohio

Overseas Highway Florida

Pacific Coast Highway/Highway 1 Coast of California

Parke County Drive Indiana

Park Loop Road Maine

Rangeley Lakes National Scenic Byway Maine

Richardson Highway Alaska

Route 6 Massachusetts and Rhode Island

Skyline Drive Virginia

Trail Ridge Road Colorado

US Route 163 Arizona to Utah

Whiteface Veterans' Memorial Highway New York

LGBTQIA-FRIENDLY TOWNS

Bangor, Maine

Eureka Springs, Arkansas

Key West, Florida

New Hope, Pennsylvania

Ogunquit, Maine

Palm Springs, California

Provincetown, Massachusetts

Saugatuck, Michigan

Water Valley, Mississippi

Wilton Manors, Florida

SMALL TOWNS WHERE ETHNIC ENCLAVES TRANSPORT YOU AND OFFER A GLOBAL PERSPECTIVE

Anadarko, Oklahoma

Artesia, California

Bay St. Louis, Mississippi

Blue Hills, Connecticut

Chimayo, New Mexico

Decorah, Iowa

El Dorado, Arkansas

Fredericksburg, Texas

Haddonfield, New Jersey

Healdsburg, California

Helen, Georgia

Hocking Hills, Ohio

Holland, Michigan

Leavenworth, Washington

Lindsborg, Kansas

Molokai, Hawaii

Montpelier, Vermont

Natchitoches, Louisiana

New Glarus, Wisconsin

New Ulm, Minnesota

Poulsbo, Washington

Solvang, California

Stanton Township, Michigan

St. Augustine, Florida

Tarpon Springs, Florida

West, Texas

TOWNS WORTH HEADING TO THE MOUNTAINS FOR

Big Bear, California

Breckenridge, Colorado

Bryson City, North Carolina

Cordova, Alaska

Dahlonega, Georgia

Deadwood, South Dakota

Durango, Colorado

Ellijay, Georgia

Eureka Springs, Arkansas

Gatlinburg, Tennessee

Holbrook, Arizona

Hood River, Oregon

Jacksonville, Oregon

Jim Thorpe, Pennsylvania

Ketchum, Idaho

Lake George, New York

Lake Placid, New York

Leavenworth, Washington

Littleton, New Hampshire

Midway, Utah

Park City, Utah

Presidio, Texas

Sonora, California

Taos, New Mexico

Telluride, Colorado

Vail, Colorado

Wears Valley, Tennessee

Whitefish, Montana

TINIEST OF TOWNS UNDER 1,000 PEOPLE

Alexandria Bay, New York 963

Berkeley Springs, West Virginia 601

Bettles, Alaska 12

Carcross, Yukon 301

Chester, Vermont 823

Dunton Hot Springs, Colorado 300

Harpers Ferry, West Virginia 281

North Haven, Maine 400

Northport, Michigan 493

Oceanside, Oregon 465

Pelee Island, Ontario, Canada 235

Point Reyes Station, California 910

Quinault, Washington 191

Tannersville, New York 582

Washington Island, Wisconsin 718

Winterthur, Delaware 53

Yosemite Valley, California 127

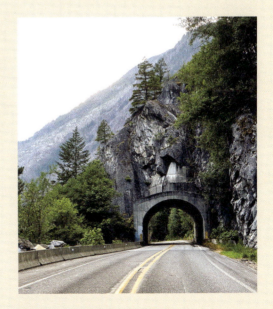

A SMALL SCRATCH ON THE SURFACE OF SMALL TOWNS
TO EXPLORE IN EVERY STATE

ALABAMA

Cullman

Dauphin Island

Eufaula

Fairhope

Fort Payne

Greensboro

Gulf Shores

Guntersville

Magnolia Springs

Mentone

Monroeville

Mooresville

Muscle Shoals

Orange Beach

ALASKA

Cordova

Girdwood

Homer

Ketchikan

Kodiak

Seward

Sitka

Skagway

Talkeetna

Unalaska

Valdez

Wrangell

ARIZONA

Arcosanti

Bisbee

Globe

Jerome

Page

Patagonia

Payson

Sedona

Tubac

Williams

Winslow

ARKANSAS

El Dorado

Eureka Springs

Jasper

Mountain Home

Searcy

CALIFORNIA

Cambria

Carmel-by-the-Sea

Dana Point

Mendocino

Mill Valley

Murphys

Sausalito

Solvang

Stinson Beach

Tahoe City

Trinidad

COLORADO

Aspen

Durango

Mancos

Manitou Springs

Ouray

Steamboat Springs

Telluride

CONNECTICUT

Bethel

Chester

Cornwall

Essex

Guilford

Kent

Litchfield

Madison

Mystic

Niantic

Noank

Norfolk

Old Saybrook

Putnam

Washington

DELAWARE

Bethany Beach

Georgetown

Lewes

Milton

New Castle

Odessa

Rehoboth Beach

Smyrna

FLORIDA

Apalachicola

Crystal River

Fernandina Beach

Key West

Mount Dora

New Port Richey

Sanibel Island

St. Augustine

Surfside

Tarpon Springs

GEORGIA

Dahlonega

Decatur

Dublin

Forsyth

Helen

Madison

Senoia

Thomasville

Tybee Island

HAWAII

Haleiwa

Hanalei

Hanapepe

Hawi

He'eia

Holualoa

Honoka'a

Lanai City

Makawao

Old Kōloa Town

IDAHO

Hailey

Ketchum

McCall

Priest River

Sandpoint

Stanley

Wallace

Weiser

ILLINOIS

Elsah

Fulton

Galena

Lebanon

Nauvoo

Ottawa

Princeton

Woodstock

INDIANA

Angola

Aurora

Corydon

French Lick

Greenfield

Madison

Nashville

New Harmony

Paoli

IOWA

Amana Colonies

Bentonsport

Decorah

Dyersville

Eldora

Fairfield

McGregor

Mount Vernon

Orange City

Pella

Winterset

KANSAS

Abilene

Council Grove

Hays

Lindsborg

Russell

Wamego

KENTUCKY

Augusta

Bardstown

Berea

Glasgow

Grand Rivers

Greenville

Hodgenville

La Grange

Midway

Pikeville

Shelbyville

Somerset

LOUISIANA

Abita Springs

Breaux Bridge

Covington

Grand Isle

Minden

Natchitoches

Saint Francisville

Thibodaux

Ville Platte

MAINE

Bar Harbor

Bath

Belfast

Bethel

Boothbay Harbor

Camden

Castine

Damariscotta

Greenville

Lubec

Rockland

Rockport

Stonington

Swans Island

Warren

Wiscasset

MARYLAND

Berlin

Chestertown

Easton

Hampstead

Havre de Grace

Leonardtown

Monkton

Ocean City

St. Mary's City

St. Michaels

Thurmont

MASSACHUSETTS

Chatham

Nantucket

Oak Bluffs

Provincetown

Rockport

Stockbridge

MICHIGAN

Alpena

Beaver Island

Charlevoix

Fishtown

Frankenmuth

Grand Haven

Leland

Mackinac Island

Marquette

Marshall

Munising

Northport

Petoskey

Saugatuck

St. Joseph

Suttons Bay

Traverse City

Weston

Ypsilanti

MINNESOTA

Biwabik

Ely

Excelsior

Grand Marais

Grand Rapids

New Ulm

Perham

Red Wing

Stillwater

Taylors Falls

MISSISSIPPI

Bay St. Louis

Clarksdale

Laurel

New Albany

Ocean Springs

Oxford

Port Gibson

Tupelo

Water Valley

MISSOURI

Arrow Rock

Clarksville

Perry

Phillipsburg

Rocheport

Sainte Genevieve

Van Buren

Weston

MONTANA

Big Sky

Ennis

Hamilton

Livingston

Philipsburg

Red Lodge

Virginia City

Whitefish

NEBRASKA

Ashland

Chadron

Monowi

Nebraska City

Valentine

NEVADA

Boulder City

Ely

Incline Village

Moapa Valley

Virginia City

NEW HAMPSHIRE

Hancock

Harrisville

Littleton

Meredith

Portsmouth

Wolfeboro

NEW JERSEY

Asbury Park

Cape May

Clinton

Edison

Lambertville

NEW MEXICO

Aztec

Cloudcroft

Galisteo

Gallup

Jemez Springs

Madrid

Red River

Santa Rosa

Silver City

Taos

Truth or Consequences

Tucumcari

NEW YORK

Alexandria Bay

Athens

Cairo

Catskill

Cold Spring

Cooperstown

Ellicottville

Hudson

Kingston

Lake George

Lake Placid

Lily Dale

Pound Ridge

Rhinebeck

Saratoga Springs

Skaneateles

Stone Ridge

Woodstock

NORTH CAROLINA

Beaufort

Blowing Rock

Boone

Brevard

Corolla

Hendersonville

Ocracoke Island

NORTH DAKOTA

Garrison

Hillsboro

Jamestown

Jud

Lisbon

Medora

Valley City

Wilton

OHIO

Chagrin Falls

Gambier

Marietta

Mount Vernon

Yellow Springs

OKLAHOMA

Broken Bow

Davis

Guthrie

Medicine Park

Pawnee

OREGON

Arcadia

Cannon Beach

Government Camp

Hood River

Independence

Jacksonville

Manzanita

Yachats

PENNSYLVANIA

Ambler

Doylestown

Jim Thorpe

Lititz

Media

New Hope

Scotland

RHODE ISLAND

Bristol

Jamestown

Little Compton

Newport

New Shoreham

Watch Hill

Westerly

SOUTH CAROLINA

Beaufort

Georgetown

Isle of Palms

Lake City

Sullivan's Island

SOUTH DAKOTA

Custer

Deadwood

Dell Rapids

Keystone

Pierre

Spearfish

Vermillion

TENNESSEE

Bell Buckle

Erwin

Gatlinburg

Granville

Hohenwald

Jonesborough

Leipers Fork

Lynchburg

Sewanee

TEXAS

Brenham

Dripping Springs

Fredericksburg

Lockhart

Marfa

Smithville

Wimberley

UTAH

Cedar City

Heber City

Kanab

Midway

Moab

Park City

VERMONT

Bennington

Chester

Dorset

Grafton

Manchester

Middlebury

Shelburne

Stowe

Waitsfield

Warren

Weston

Woodstock

VIRGINIA

Abingdon

Chincoteague

Culpeper

Lexington

Luray

Middleburg

Staunton

WASHINGTON

Friday Harbor

Leavenworth

Orcas Island

Port Townsend

Skagit Valley

Union

WEST VIRGINIA

Berkeley Springs

Harpers Ferry

Lewisburg

Shepherdstown

Snowshoe

WISCONSIN

Hayward

Mineral Point

Osceola

Spring Green

Stockholm

WYOMING

Buffalo

Dubois

Hulett

Jackson Hole

Lander

Pinedale

Powell

Sheridan

Sundance

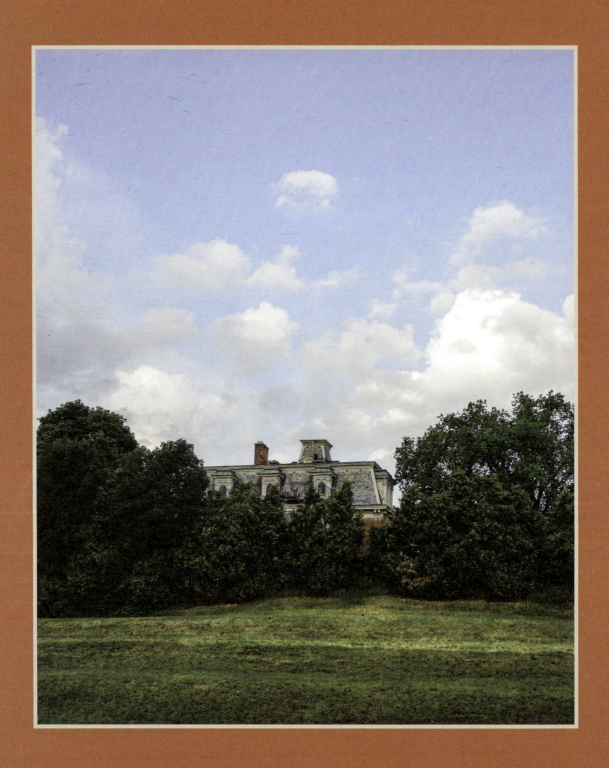

ACKNOWLEDGMENTS

Thank you to my husband Sean and son Tom Otis. Their love for exploring and living in a small town makes our small town journey so joyous! I look forward to further small town adventures with you both. For my mom, Dorothy Abbott, who raised me in a small town and instilled a lifelong love for the community that a small town provides. Thank you to my agents, Kim Perel and Margaret Danko. Your support and encouragement are completely unmatched. I'm so thankful for you both. To my editor, Shannon Connors Fabricant, and the Running Press team, thank you for believing in this project and my ability to tell the story of small towns.

To my own small town communities of Water Valley, Oxford, and Taylor, Mississippi: the places and the people who call them home have my heart; your creative spirit and desire to make where we live a more interesting and creative place gives me endless inspiration. Thank you to the readers: your interest in small towns, and the special kind of magic that each town holds, is what made this book possible. And lastly, a special thank you to the people who let me tell their small town stories within this book. Thank you for opening your homes and sharing your towns with all of us. This book couldn't have been possible without you.

INDEX